PAINTING GOURDS

10 PROJECTS

WITH THE FAIRY GOURDMOTHER®

Sammie Crawford

Schiffer Publishing Ltd

4880 Lower Valley Road • Atglen, PA 19310

Other Schiffer Books by the Author:
Creating Gourd Birds with the Fairy Gourdmother®, 978-0-7643-3735-2, $24.99
Building Gourd Birdhouses with the Fairy Gourdmother®, 978-0-7643-3736-9, $24.99
Gourd Fun for Everyone, 978-0-7643-3124-4, $22.99
Holiday Fun: Painting Christmas Gourds, 978-0-7643-3279-1, $14.99
Making Gourd Bowls with the Fairy Gourdmother®, 978-0-7643-3980-6, $16.99
Time for Gourds: 8 Clock Projects, 978-0-7643-3981-3, $16.99

Other Schiffer Books on Related Subjects:
Gourd Crafts: 6 Projects and Patterns, 978-0-7643-2825-1, $14.95
Apples to Apples: Basic Techniques for Decorating Gourds, 978-0-7643-3621-8, $19.99
One Gourd at a Time: A Beginner's Guide, 978-0-7643-4146-5, $24.99

Published by Schiffer Publishing, Ltd.
4880 Lower Valley Road
Atglen, PA 19310
Phone: (610) 593-1777; Fax: (610) 593-2002
E-mail: Info@schifferbooks.com

For the largest selection of fine reference books on this and related subjects,
please visit our website at:
www.schifferbooks.com.
You may also write for a free catalog.

This book may be purchased from the publisher.
Please try your bookstore first.

We are always looking for people to write books on new and related
subjects. If you have an idea for a book, please contact us at:
proposals@schifferbooks.com.

Schiffer Books are available at special discounts for bulk purchases for
sales promotions or premiums. Special editions, including personalized
covers, corporate imprints, and excerpts can be created in large
quantities for special needs. For more information contact the publisher.

In Europe, Schiffer books are distributed by
Bushwood Books
6 Marksbury Ave.
Kew Gardens
Surrey TW9 4JF England
Phone: 44 (0) 20 8392 8585; Fax: 44 (0) 20 8392 9876
E-mail: info@bushwoodbooks.co.uk
Website: www.bushwoodbooks.co.uk

Designed by RoS
Type set in Cooper Blk BT/NewBskvll BT

ISBN: 978-0-7643-4309-4
Printed in China

Different Strokes©buttershug;
Paintbrushes on white©elenathewise;
Abstraction©velkol.
All images courtesy of BigstockPhoto.com.

Contents

Every gourd is different and, because they're different, the patterns in this book will require some adjustment, whether it's enlarging or reducing them to fit your particular gourd. The best way to apply a flat pattern to a round surface is to cut the pattern tracing into pieces and apply the individual features where needed.

Gourds are almost all water when green. To dry out to the stage where we can use them, all that water has to evaporate through the skin. In the process, they turn black and moldy. This is when first-time growers throw them away, thinking that they are ruined, when actually it's just a necessary step in the process.

When they are light and the seeds rattle (usually), it's time to clean all that mold off. Soak them in the sink in a little water and bleach for a few minutes to soften the skin. They float like corks so turn them occasionally to get them wet all over. Use a plastic scrubber; most of the skin will come right off. Remove any stubborn spots with a dull paring knife. Get the gourd completely clean because anything left can flake off later and take all your hard work and paint with it. Once clean and dry, you're ready to paint.

Your "usual painting supplies" should include tracing paper, transfer paper in black and white, palette paper, a divided water tub or two water containers, Q-tips, good grade paper towels, stylus, palette knife, short flexible ruler, kneaded eraser, sponge, and pencils, charcoal, and chalk pencils. Now you only have to add the brushes and paints and you're ready to go.

Getting Started

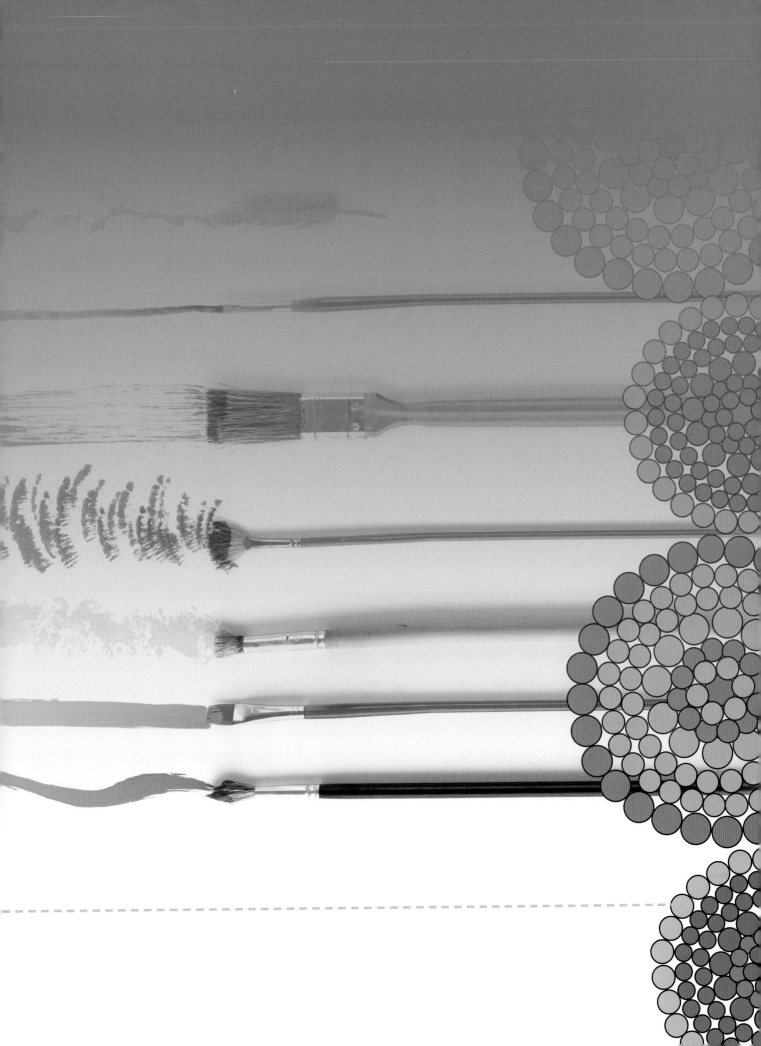

PALETTE
Delta Ceramcoat

– Brown Iron Oxide
– Light Chocolate
– Light Foliage
– Medium Foliage
– Dark Foliage
– Butter
– Toffee
– Black
– White
– Walnut

BRUSHES
Loew-Cornell

– Series 7300 # 2, 12 flats
– Series 7350 10/0 liner
– Series 7520 1/2" rake
– Series 7550 1" wash brush

SUPPLIES

– 8-9" bottle gourd
– Satin spray varnish

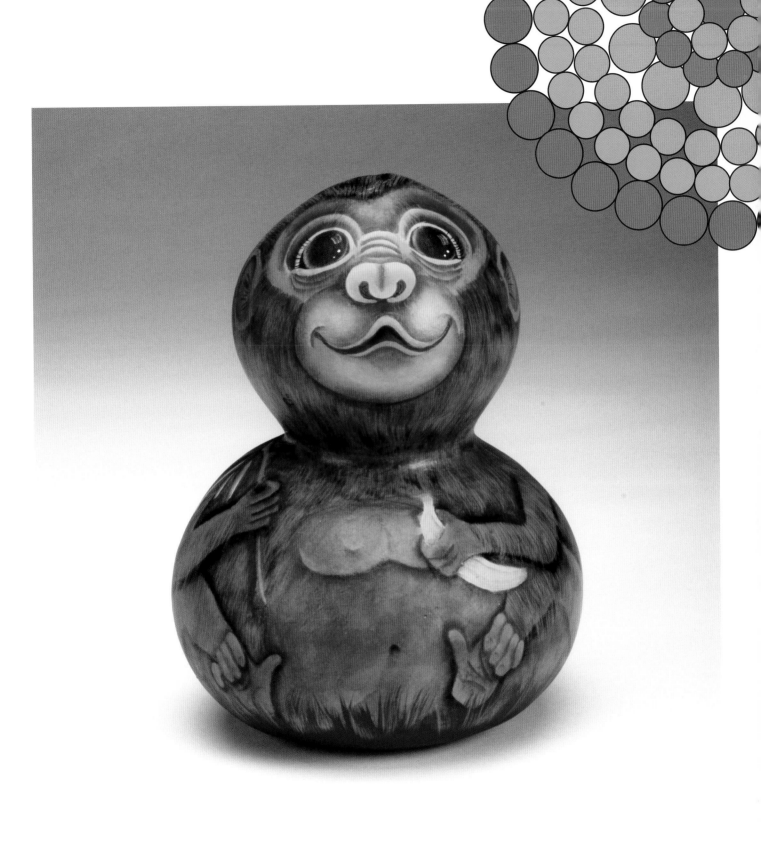

Baby Chimp

PAINTING the PIECE

1 Basecoat the entire gourd with Toffee and then apply the pattern.

2 Use the rake brush and Brown Iron Oxide to make the first layer of hair. The second layer and the eyes are Walnut, and base the banana with Butter.

3 Base the grass Dark Foliage keeping the edges ragged.

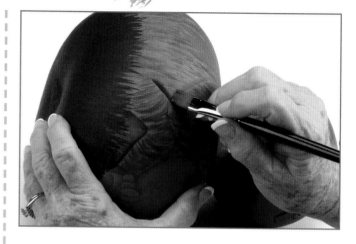

4 Use the #12 flat and Walnut to shade around the limbs.

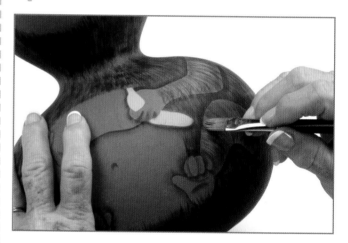

5 Use Light Chocolate to highlight the tops of the limbs.

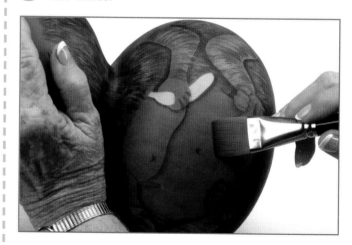

6 Use the wash brush and Walnut to wash the tummy area.

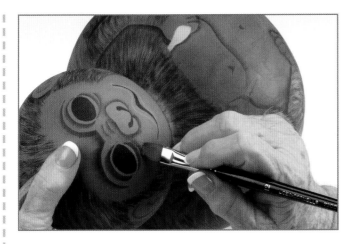

7 Use the #12 flat and Brown Iron Oxide to shade the wrinkles and around the facial features.

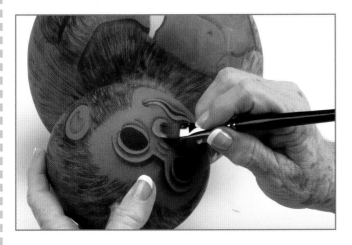

8 Use Light Chocolate to highlight the features.

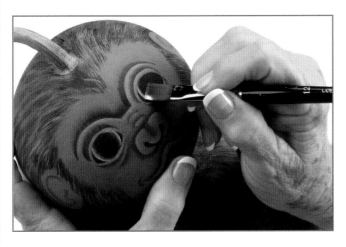

9 Use the # 12 flat and White to float C strokes in each corner of the eye to make it appear round.

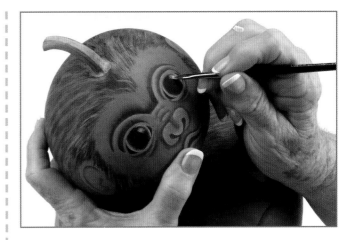

10 Use the # 2 flat and White to place a rectangular shine in the eyes.

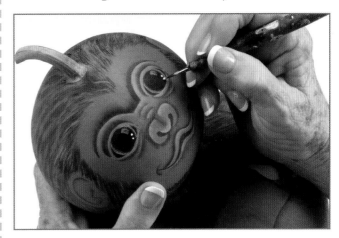

11 Use the stylus brush and White to place dots in each eye.

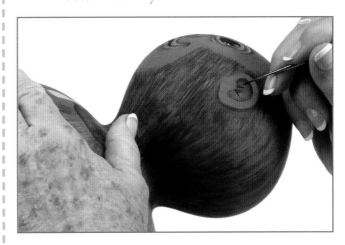

12 Use the liner brush and Brown Iron Oxide to pull hairs from the ears.

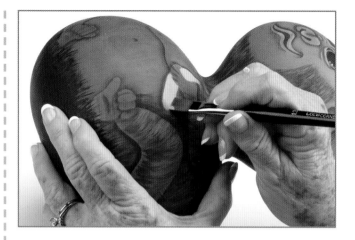

13 Use the # 12 flat and Light Foliage to float each end of the banana.

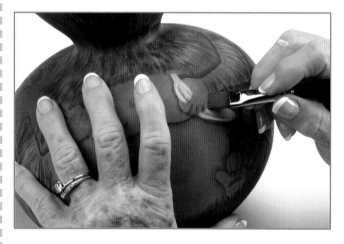

14 Float Brown Iron Oxide lines down the banana.

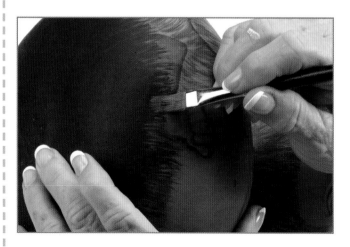

15 Use the rake brush and Medium Foliage plus a little Light Foliage to pull grass blades up from the base.

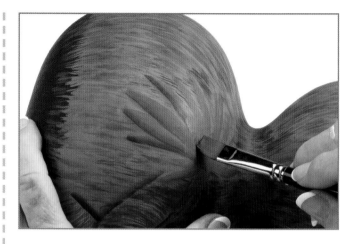

16 Shade the Medium Foliage palm frond using Dark Foliage and the # 12 flat.

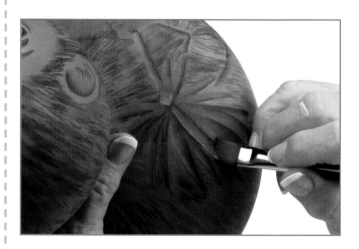

17 Highlight the palm frond using Light Foliage and the same brush. Finish with several light coats of spray varnish.

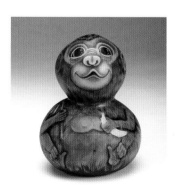

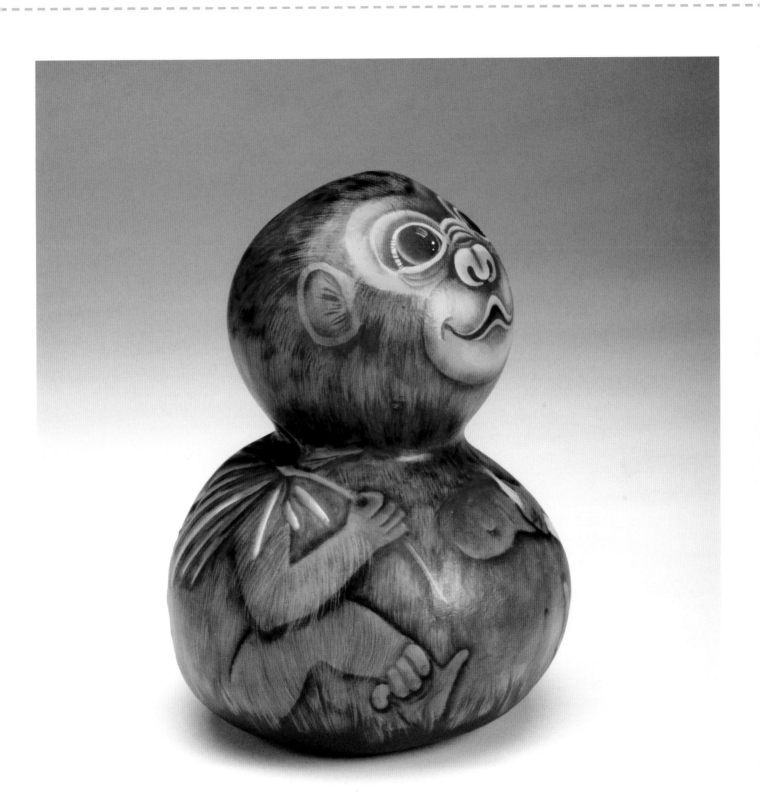

12

PALETTE
Delta Ceramcoat

- White
- Black
- Bittersweet
- Adobe
- Black Cherry
- Spice Brown
- Opaque Red
- Bridgeport Grey
- Terra Cotta
- Light Foliage
- Medium Foliage
- Dark Foliage
- Nightfall
- Spice Tan

BRUSHES
Loew-Cornell

- Series 7300 #6, 12 flats
- Series 7350 10/0 liner
- Series 7550 1" wash
- #275 1/2" mop

SUPPLIES

- Mexican Bottle gourd
- 2 round gourds
- Gourd pieces
- Blending gel
- Craft saw
- Wood glue
- Fast n' Final spackle
- Fine grit sandpaper
- Satin spray varnish

Assembly

Cut a ring from a cylindrical gourd piece for the hat band. Slice a thin piece of the bottom of each round gourd so that they will sit better on top of the bottle gourd and glue in place. Place the gourd ring between the two round gourds as you glue. Allow to dry several hours or overnight. Spackle the joints and sand smooth when dry. *See illustration on page 60.*

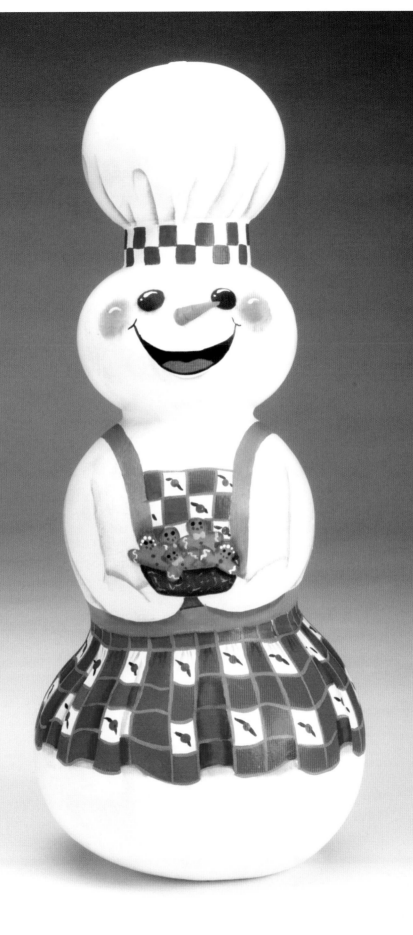

Baker Snowman

PAINTING the PIECE

Use the wash brush and White to paint the entire piece. Apply the pattern and use the #6 flat and Opaque Red to paint the hat band; start in the back in case you come out uneven. Base the nose Bittersweet, the eyes and mouth Black, the apron straps Medium Foliage, the bowl Nightfall, the gingerbread men Spice Tan, and the apron stripes Opaque Red.

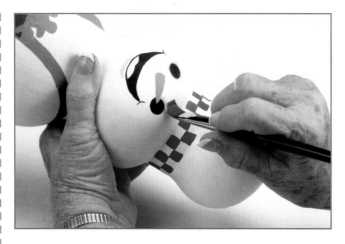

1 Use the # 12 and Bridgeport Grey to float a shadow around each eye.

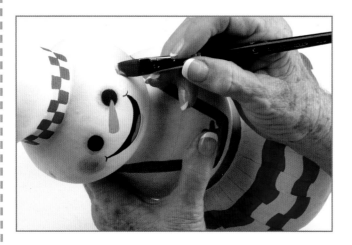

2 Apply blending gel to each cheek and tap in Adobe. Soften the circle with the mop brush.

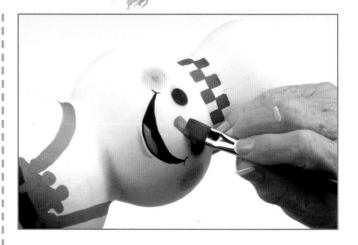

3 Shade the nose with Terra Cotta using the #12 flat.

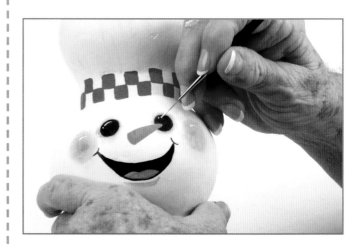

4 Use the liner brush and White to place a comma stroke in each eye.

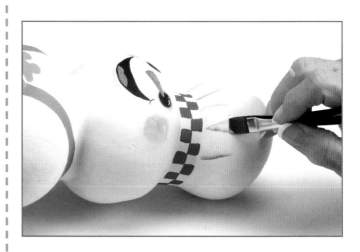

5 Float Bridgeport gathers in the hat.

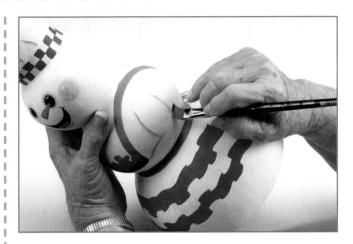

6 Use the same brush and color to shade around the arms.

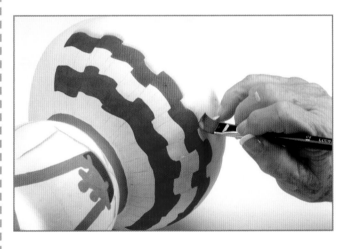

7 Use the #12 flat and Bridgeport to shade under the apron.

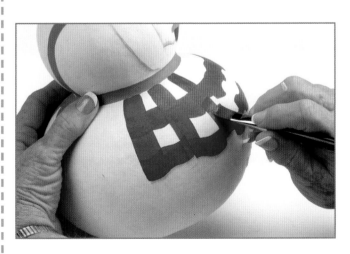

8 Use the #12 flat and Opaque Red to paint the vertical stripes in the apron.

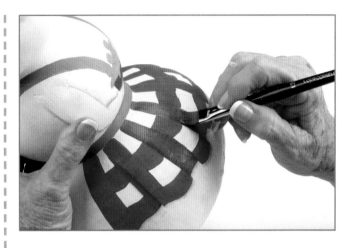

9 Shade the red gathers in the apron with Black Cherry.

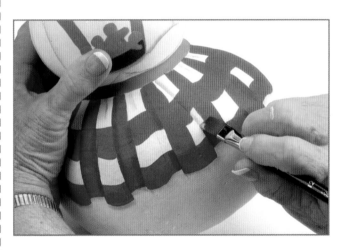

10 Shade the white gathers in the apron with Bridgeport Grey.

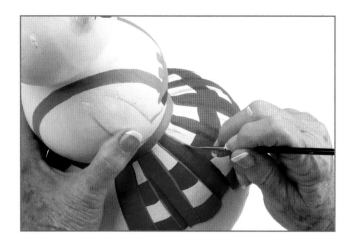 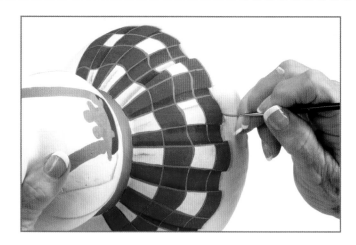

11 Use the liner brush and Light Foliage to add the final stripes to the apron.

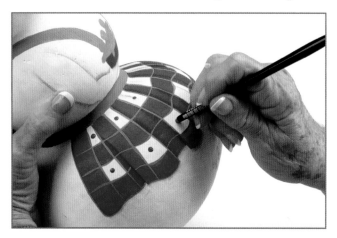

12 Use the end of the brush to apply the Opaque Red dots to the center of the squares.

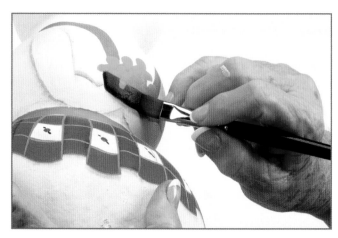

14 Shade the bottom of the bowl with Black.

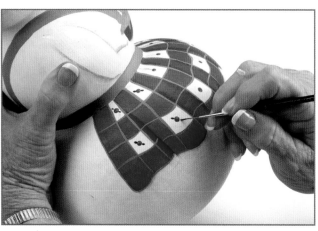

13 Use the liner brush and Light Foliage to add the leaves to the dots.

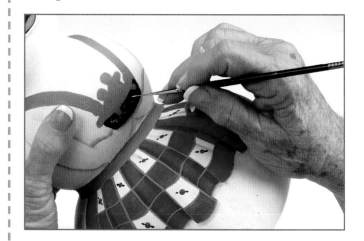

15 Use the liner brush and White to add squiggles to the bowl.

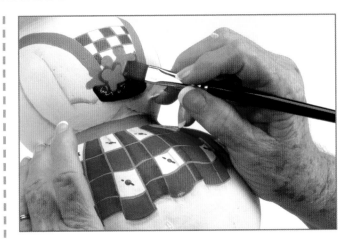

16 Shade the gingerbread people with Spice Brown.

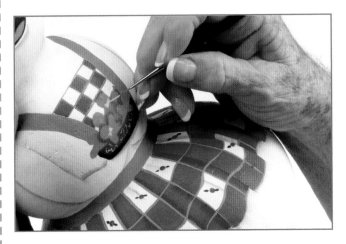

17 Use the liner brush and Light Foliage to add bow ties and ribbons on the gingerbread people.

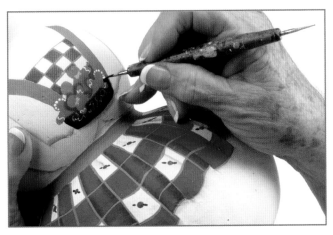

18 Use the stylus and Opaque Red to add dots to the gingerbread.

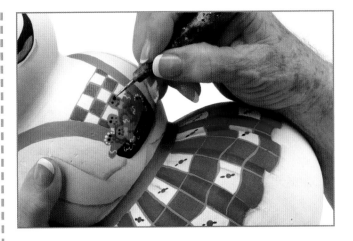

19 Us the stylus and Black to add eyes to the gingerbread.

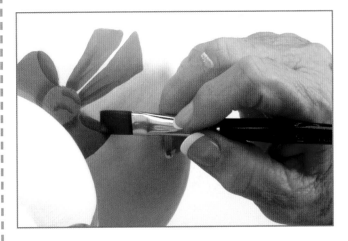

20 Shade the apron ties with Dark Foliage.

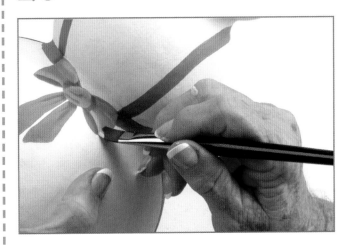

21 Highlight the ties with Light Foliage. Finish with several light coats of spray varnish.

PALETTE
Delta Ceramcoat

- Black
- Roman Stucco
- White
- Pink Quartz
- Territorial Beige
- Burnt Sienna
- Storm Grey
- Rain Grey
- Wild Rose
- Raw Sienna
- Medium Flesh
- Ultra Blue
- Santa's Flesh
- 14k Gold
- Autumn Brown

BRUSHES
Loew-Cornell

- Series 7300 #2, 12 flat shaders
- Series 7350 10/0 liner
- Series 7550 1" wash
- #275 1/2" mop

SUPPLIES

- 8" tall pear shaped gourd
- Egg gourd
- Felt hat (craft store item)
- Small frog
- Glue gun
- Stylus
- Wood glue
- Grey rabbit pelt
- Blending gel
- Satin spray varnish

Assembly

Cut a small slice off the end of the egg gourd and glue to the top of the pear gourd. *See illustration on page 62.*

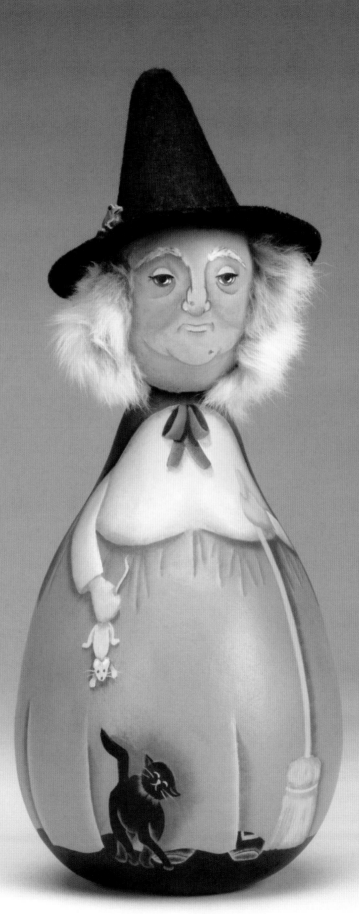

Witch with Rat and Cat

PAINTING the PIECE

Apply the pattern and basecoat the head Medium Flesh, the cape Storm Grey, the skirt Rain Grey, the broom Roman Stucco, the cat Black, the rat a mix of Rain Grey and White 1:1, and the blouse a mix of Pink Quartz, White, and Territorial Beige 3:2:1.

1 Outline the features using the liner brush and thinned Burnt Sienna.

2 Shade under the brow, down each side of the bridge of the nose, in the wrinkles, and under the chin with a mix of Georgia Clay + Medium Flesh + Autumn Brown 2:1:*. *Note: The (*) denotes a touch of Autumn Brown.*

3 Highlight down the bridge of the nose in the wrinkles and above the chin line with Santa's Flesh.

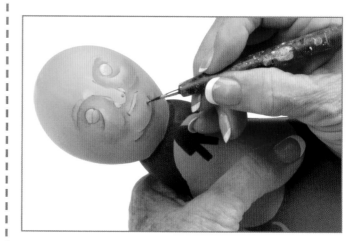

4 Use the stylus and Burnt Sienna to place the warts on her nose and chin.

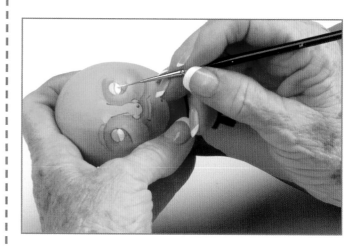

5 Fill the eyes in solid with White.

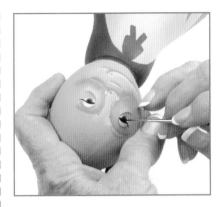

6 Paint the irises Storm Grey with Black pupils.

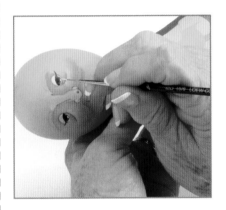

7 Use the liner brush and thinned White to place a comma stroke in each eye.

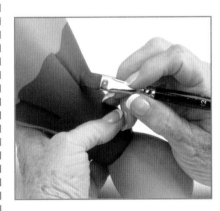

8 Shade the folds in the cape with Black using the #12 shader.

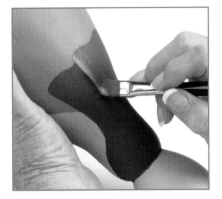

9 Highlight the folds using Rain Grey and then use the 1" wash brush to wash the cape with thinned Storm Grey.

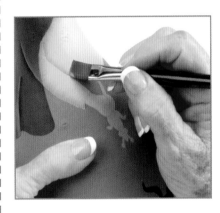

10 Shade the blouse with Wild Rose.

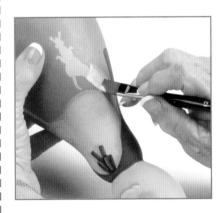

11 Highlight the blouse with a mix of Rose Cloud and White 1:1.

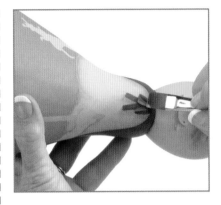

12 Shade the tie with Black and highlight with Rain Grey.

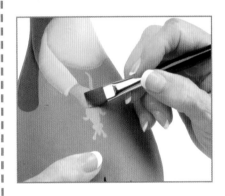

13 Shade the hand with the shading mix you used on the face.

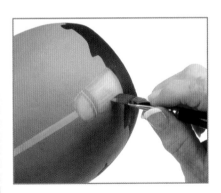

14 Shade the broom with Raw Sienna.

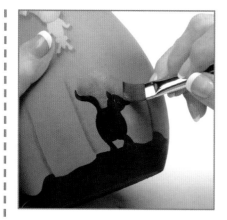

15 Brush blending gel around the cat and shade on the skirt around the cat with Storm Grey. Mop to soften the shadow.

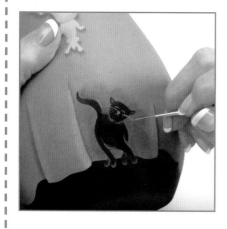

16 Float Rain Grey under the cat's chin and use the 10/0 liner and same color for the features.

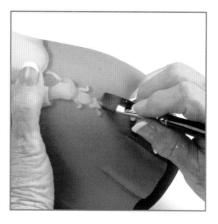

17 Shade the rat with Rain Grey and float a tiny bit of Pink Quartz inside the ears.

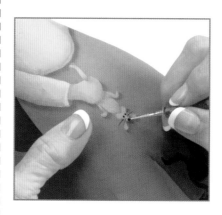

18 Use the stylus and Black to make the rat's eyes and nose.

19 Shade down beside the broom handle with Storm Grey.

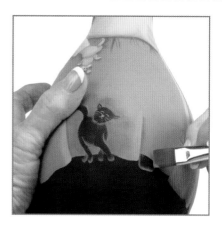

20 Use Rain Grey to float the shadow of the shoe.

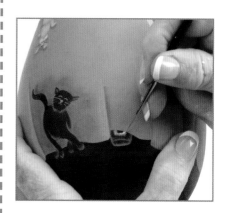

21 Use 14k Gold to paint the buckle on the shoe.

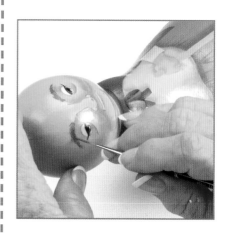

22 Use the liner brush and Storm Grey to make the eyebrows.

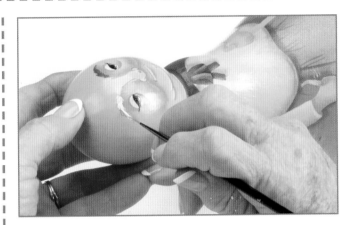

23 Use the same brush and White to over paint the brows leaving some of the grey showing. Finish with several light coats of spray varnish.

24 Place the hat on the head and draw around under the brim for hair placement.

25 Measure and mark the piece needed on the back side of the fur.

26 Hold the fur up off the table and cut the pelt with a craft knife or razor blade.

27 Use the glue gun to adhere the fur piece to the gourd.

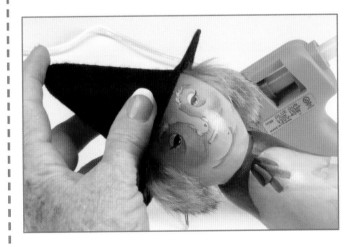

28 Glue the hat on and glue the small frog to the hat brim.

PALETTE
Delta Ceramcoat

- Opaque Red
- 14k Gold
- Dark Foliage
- Light Foliage
- Black Green
- White Dolphin
- Candy Bar Brown

BRUSHES
Loew-Cornell

- Series 7000 #4 round
- Series 7300 #12 flat
- Series 7350 10/0 liner
- Series 7550 1" wash brush
- #275 1/2" mop

SUPPLIES

- 6-7" diameter canteen or tobacco box gourd, minimum 4" deep
- Oil lamp insert*
- Drill & 5/8" bit
- Gloss spray varnish

* Available from david@ turtlefeathers.net or 1-828-488-8586

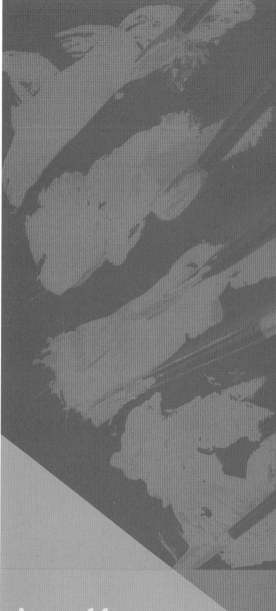

Assembly

Drill the hole in the center of the gourd for the lamp insert *See illustration on page 63.*

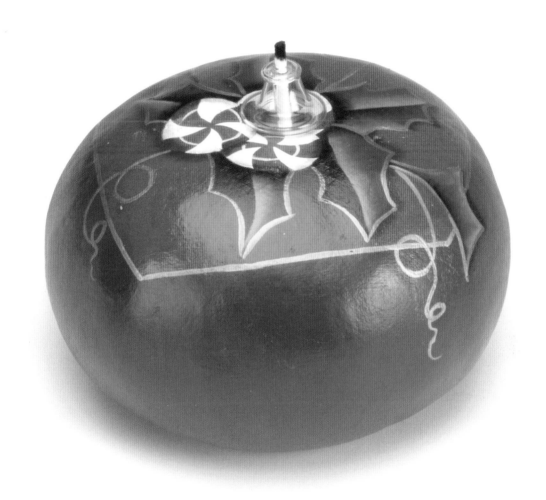

Christmas Oil Lamp

PAINTING the PIECE

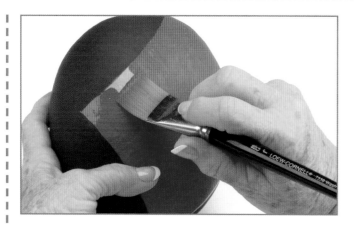

1 Apply the pattern and use the wash brush to basecoat the bottom Dark Foliage and the diamond on top Opaque Red.

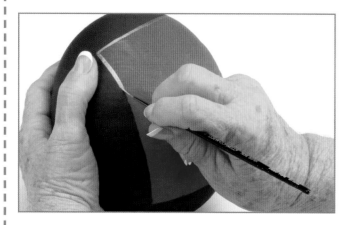

2 Use the liner brush and 14k Gold to paint the border around the diamond.

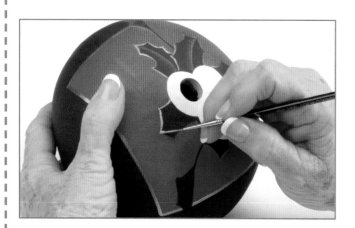

3 Paint the candies White and the leaves Dark Foliage. Use the liner brush and 14k Gold to outline the leaves and add gold squiggles.

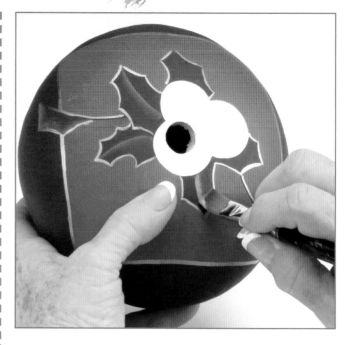

4 Highlight the leaves with Light Foliage using the #12 flat brush.

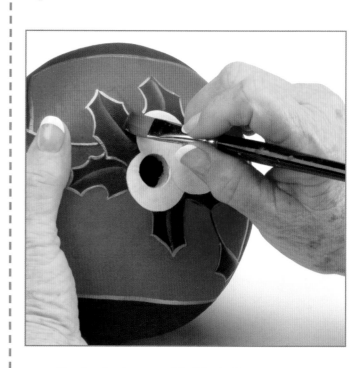

5 Shade the leaves with Black Green.

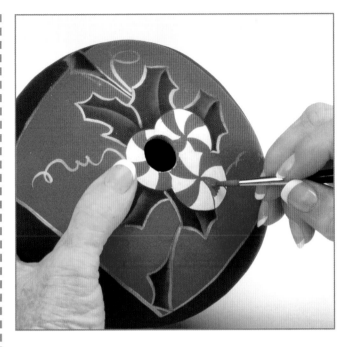

6 Use the round brush and Opaque Red to paint every other section of the candies.

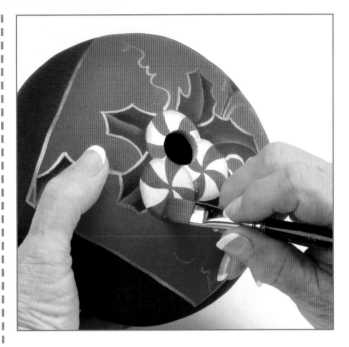

8 Use Candy Bar to shade the red sections of the candies.

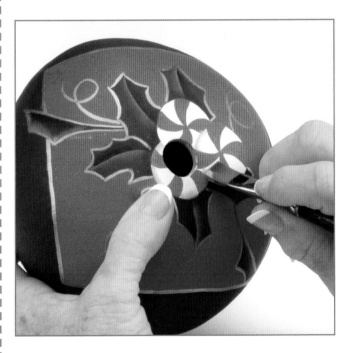

7 Use Dolphin Grey to shade the white sections of the candies.

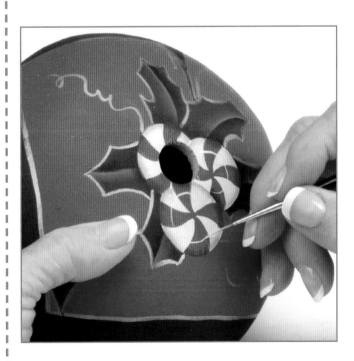

9 Use the 10/0 liner and White for the "shine" on the red sections. Finish with several light coats of spray varnish. Insert oil lamp into hole.

PAINTING the PIECE

PALETTE
Delta Ceramcoat

–Burnt Sienna
–Raw Sienna
–Black

BRUSHES
Loew-Cornell

–Series 7350 10/0 liner
–Series 7550 1" wash brush
–Series 7500 # 4 filbert

SUPPLIES

–Martinhouse or kettle gourd, any size
–Plastic sack or Saran Wrap®
–Blending gel
–1/4" plywood
–Wood glue
–Craft saw
–Drill and 1/2" bit
–Fast n' Final spackle
–Medium grit sandpaper
–Satin spray varnish

Assembly

Cut the top off the gourd at the neck the cut and then cut the gourd in half from top to bottom. Place half of the gourd on the plywood and draw around it. Allowing for the thickness of the gourd, draw a second line inside the first one. Cut out the shape using the second line. Trim or sand to make the plywood fit just inside the back of the gourd. Drill a hole in the center near the top of the wood for hanging then glue the wood in place. Spackle any cracks and sand when dry. *See illustration on page 64.*

1 Wash the entire gourd with Raw Sienna and paint the back. Apply blending gel to the front and cover the surface with Burnt Sienna. Crumple the plastic sack and dab all over to get a leather look. Allow to dry.

2 Use the wash brush and Black to float a wide shadow fading down at the neck of the gourd.

3 Apply the pattern and use the filbert and Black to paint the figures. Use the liner brush for the fine lines. Finish with several light coats of spray varnish.

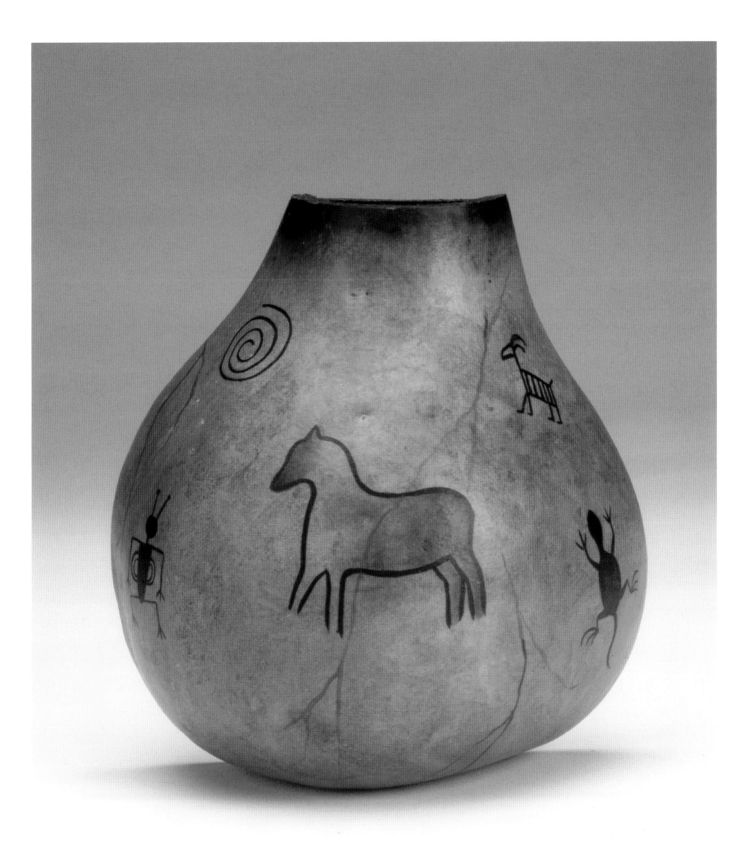

Petroglyph Wall Pocket

PALETTE
Delta Ceramcoat

–Mudstone
–White
–Dark Goldenrod
–Dark Victorian Teal
–Black
–Dark Flesh
–Golden Brown

BRUSHES
Loew-Cornell

–Series 7300 # 12 flat
–Series 7350 10/0 liner
–Series 7500 # 6 filbert
–Series 7550 1" wash brush

SUPPLIES

–8-10" martinhouse or kettle gourd
–Wood glue
–Craft saw
–Medium grit sandpaper
–1/4" plywood
–Drill and 1/2" bit
–Gloss spray varnish
–Fast n' Final spackle

Assembly

Follow the instructions for the Petroglyph Wall Pocket on page 28. *See illustration on page 65.*

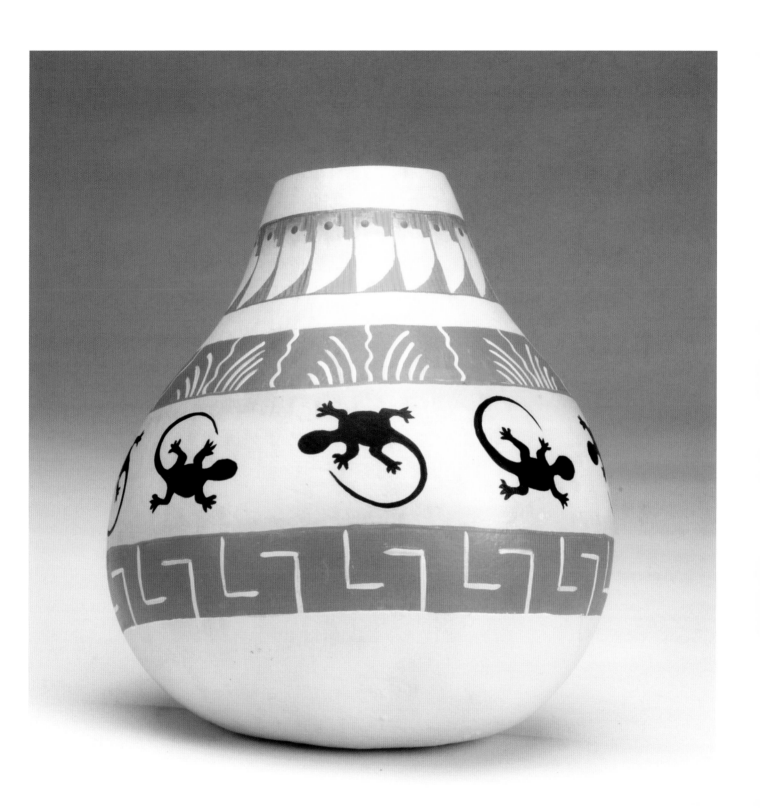

Southwest Wall Pocket

PAINTING the PIECE

Basecoat the entire gourd with a mix of Mudstone and White 1:2. Apply the pattern and paint the top band Dark Goldenrod and the other two bands Dark Flesh.

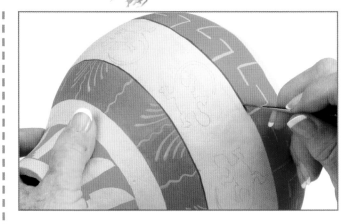

3 Use the liner brush and Dark Victorian Teal to paint the lines on the edges of the space between the middle and bottom bands.

1 Use the liner brush and the Mudstone mix to make the lines on the bottom band.

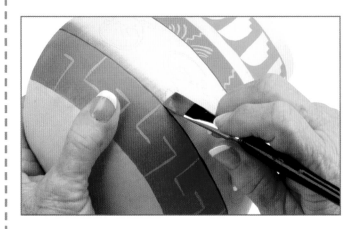

4 Use the # 12 flat and the same color to float against the narrow blue lines.

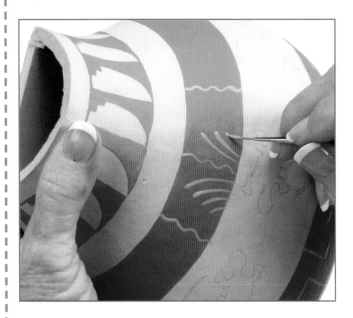

2 The middle band is done the same way with the same color and brush.

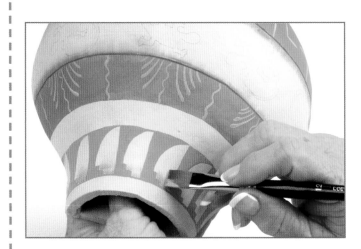

5 Use the #12 flat and a mix of Dark Victorian Teal and White 1:1 to shade down to the second notch.

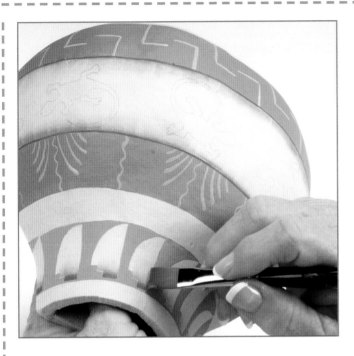

6 Shade down to the first notch with Dark Victorian Teal.

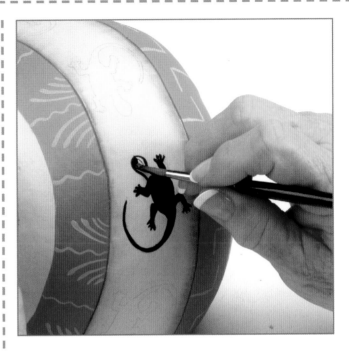

8 Use the filbert and liner brushes to fill the lizard in solid with Black.

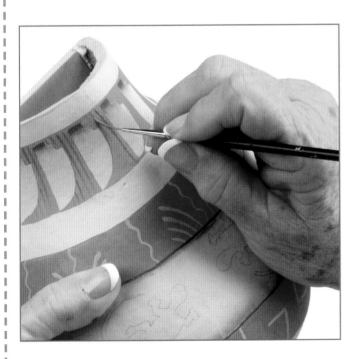

7 Use the liner brush and Golden Brown to make the thin lines on the Dark Flesh band.

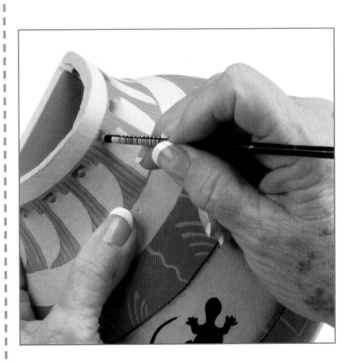

9 Use the brush handle and Golden Brown to place the dots on the top band. Finish with several light coats of spray varnish.

PALETTE
Delta Ceramcoat

- Black
- White
- Passion
- Pumpkin
- Straw
- Medium Flesh
- Georgia Clay
- Autumn Brown
- GP Purple
- Adobe
- Dark Brown
- Ivory
- 14k Gold
- Red Iron Oxide
- Medium Foliage
- Golden Brown
- Purple

BRUSHES
Loew-Cornell

- Series 7300 #12 flat
- Series 7350 10/0 liner
- Series 7500 #6 filbert
- #275 1/2" mop

SUPPLIES

- 2 club gourds
- Egg gourd
- Flat gourd scrap
- Wood glue
- Blending gel
- Novelty bell
- Craft saw
- 1/4" plywood scrap
- Fast n' Final lightweight spackle
- Delta star stencil # 45 324 0412
- Satin spray varnish
- Bird shot or kitty litter (optional)

Assembly

Cut the bottom off one club gourd to make it stand. Place the cut end on the plywood and draw around it. Follow the instructions in Petroglyph Wall Pocket for making it fit the gourd. If the gourd seems too light, place some bird shot or kitty litter inside and then glue the plywood piece in place.

Cut a small hole in the bottom of the egg gourd so it will fit on the end of the club gourd; glue in place. Cut off a section of the second club gourd for a hat. Set the cone on the flat piece of gourd scrap and draw a circle then draw a second circle about 1" larger for the outer edge of the brim. Cut the brim out but cut the center circle slightly smaller than you think you need. It is much easier to recut or sand than to add back. You want the brim to just slide down and fit at the bottom of the cone. Glue and when dry, spackle any seams where the two pieces meet. Do not glue the hat on until the painting is finished. *See illustration on page 66.*

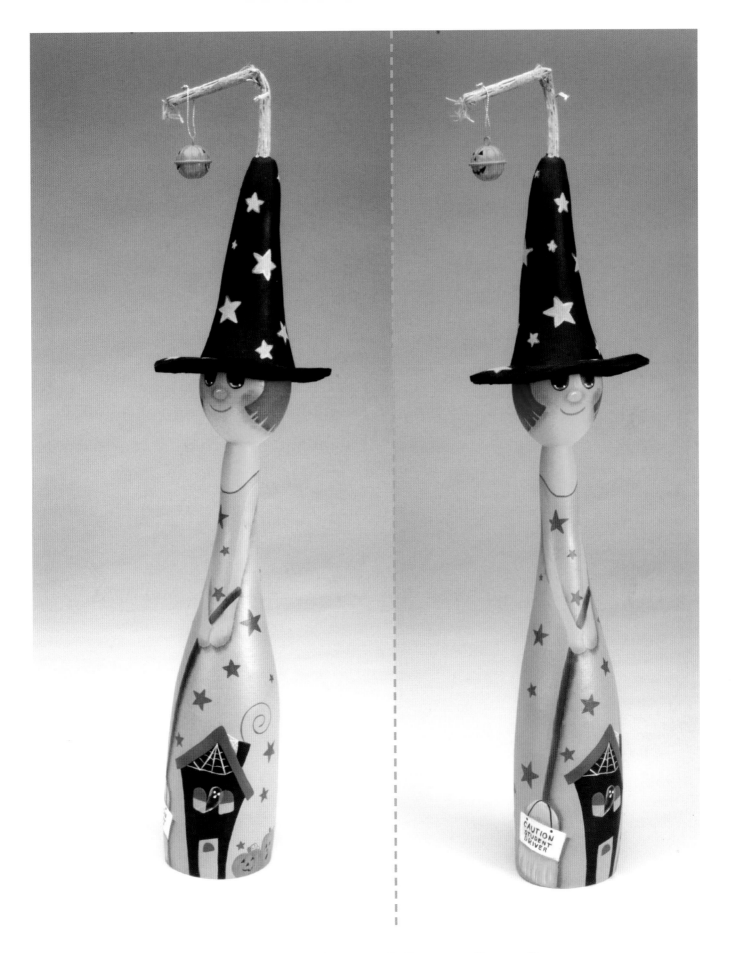

Witch in Training

PAINTING the PIECE

Apply the pattern and paint all flesh Medium Flesh, the dress GP Purple, and the hair Georgia Clay. Basecoat the broom handle Dark Brown with Straw bristles. The sign is White. Paint the house Black with a Passion roof and shades.

1 Use the stencil and a white chalk pencil to place stars randomly on the hat.

2 Paint the stars GP Purple.

3 Use the liner brush and 14k Gold to outline the stars.

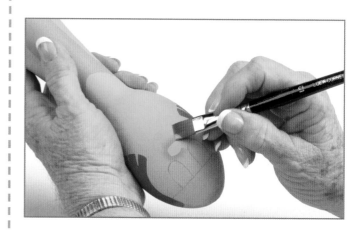

4 Use the #12 flat and a mix of Georgia Clay, Medium Flesh, and Autumn Brown 2:1:* to shade around the nose, under the hair, and on the bottoms of the hands. *Note: The (*) denotes a touch of Autumn Brown.*

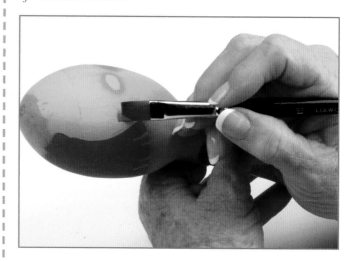

5 Apply blending gel to the cheeks and dab in Adobe. Use the mop to soften and blend.

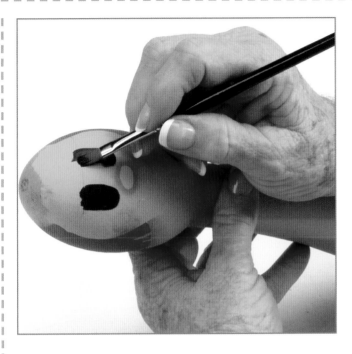

6 Place the hat on the head and draw a line on the face under the brim. Use the filbert and Black to fill the eyes in solid and extending up under the hat brim.

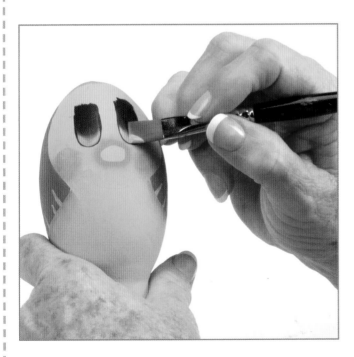

7 Use the #12 flat to place a float of GP Purple across the bottom of the eyes.

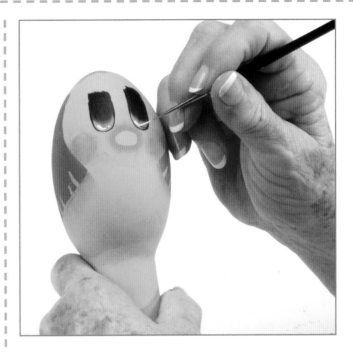

8 Use the liner brush and White to place a comma stroke in each eye.

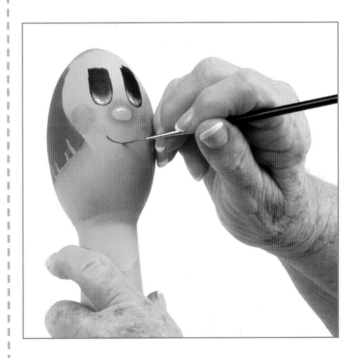

9 Use the liner brush and Adobe to make the mouth.

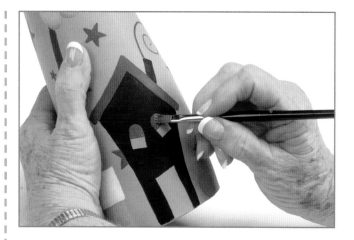

10 The door and windows are GP Purple. The stars on the dress are Passion.

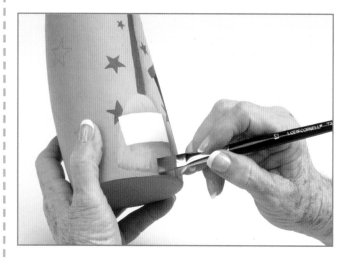

11 Shade the broom and under the sign with Golden Brown.

12 Highlight the broom with Ivory.

13 The lettering on the sign is done with Black and the liner brush.

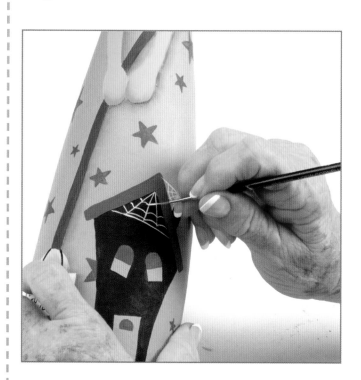

14 Use the liner brush and White to paint the cobwebs.

15 Use the #12 flat and White to float the ghost. Use the liner brush to make his features.

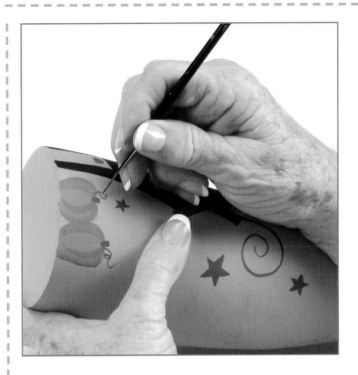

17 The stems are Medium Foliage.

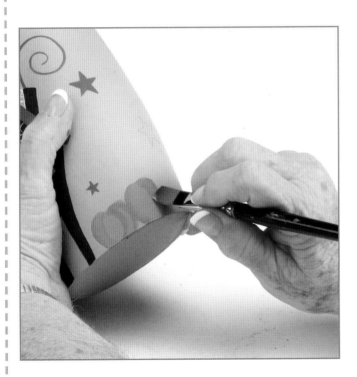

16 Base the pumpkins with Pumpkin (what else?) and shade with Georgia Clay using the #12 flat.

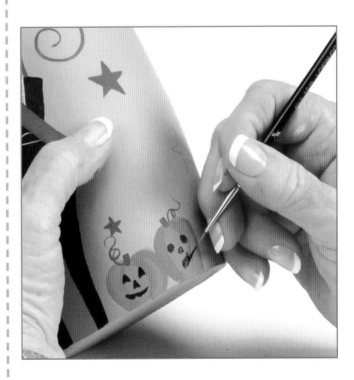

18 Use the liner brush and Black to make the features. Finish with several light coats of spray varnish.

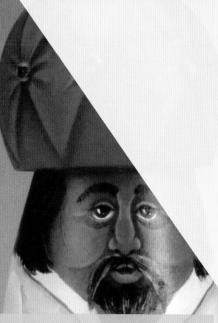

PALETTE
Delta Ceramcoat

- Moroccan Red
- Autumn Brown
- Brown Iron Oxide
- Candy Bar Brown
- Old Parchment
- Light Chocolate
- Bridgeport Grey
- Raw Sienna
- Burnt Sienna
- Adobe
- Black
- Spice Tan
- Light Ivory
- Bright Red
- 14k Gold
- Laguna
- Fiesta Pink

Assembly

Cut the top of the club gourd off and cut a circle of plywood to fit in the hole. Cut the bottom and top off the bottle gourd and slip onto the top of the club gourd per diagram. Glue all pieces in place and apply the pattern when dry. *See illustration on page 68.*

BRUSHES
Loew-Cornell

- Series 7300 #12 flat
- Series 7350 10/0 liner
- Series 7520 1/2" filbert rake
- Series 7550 1" wash brush
- #275 1/2" mop

SUPPLIES

- 11-13" tall club gourd
- Bottle gourd pieces
- Glue gun
- White chalk pencil
- Craft knife or saw
- Scrap 1/4' plywood
- Silver cord (optional)
- Wood glue
- Blending gel
- Satin spray varnish
- Red and clear rhinestones

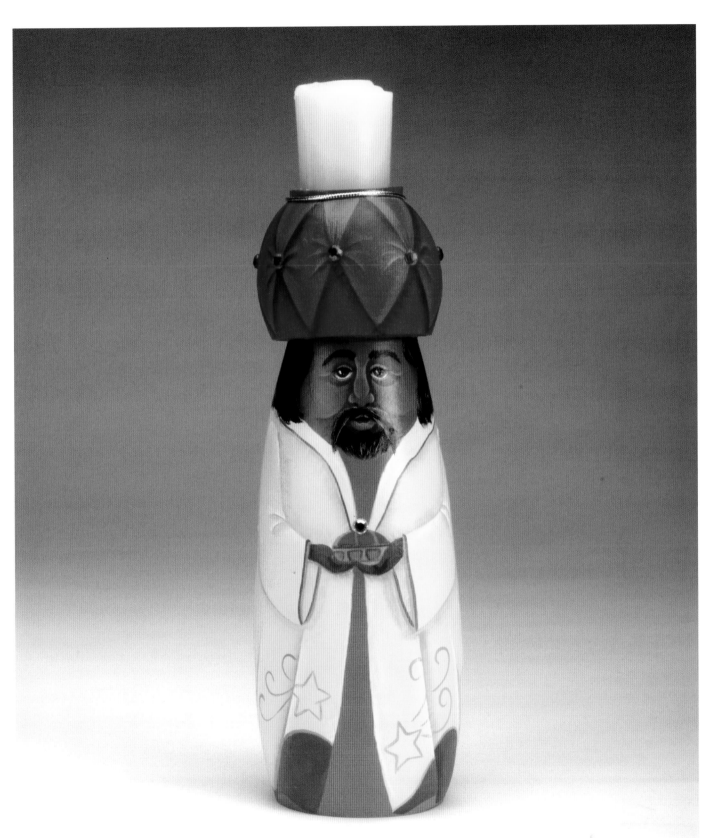

Yellow Magi

PAINTING the PIECE

Basecoat the turban and robe border Moroccan Red, the face and hands with Autumn Brown, the robe with Old Parchment, the hair Black, the box Spice Tan and the gown a mix of Bright Red + Fiesta Pink 1:1. Use the chalk pencil and place dots top and bottom to divide the turban into eight equal sections. Draw "x"s using the dot as guides. This produces the diamond pattern on the turban.

3 The light part of the robe is shaded with Spice Tan.

1 Use the #12 flat and Candy Bar Brown to shade the turban.

4 Highlight the robe with Light Ivory.

2 Highlight the turban with Adobe.

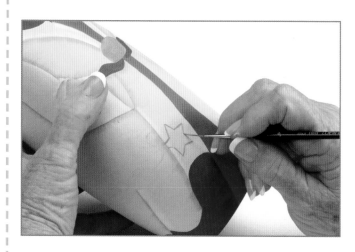

5 The line work at the bottom of the robe is done with the liner brush and Spice Tan.

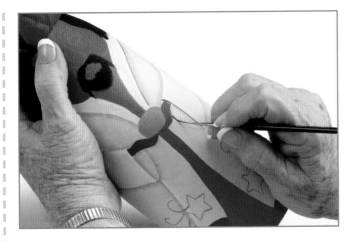

6 The line work on the sleeves and collar is done with Moroccan Red.

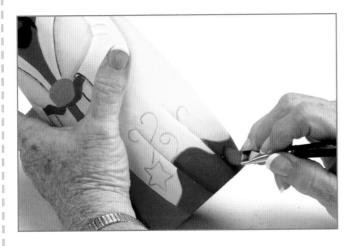

7 Shade the red part of the robe with Candy Bar.

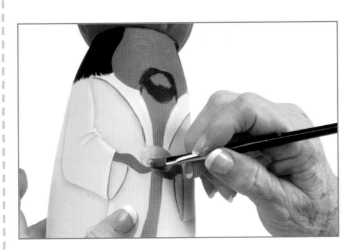

8 Overpaint the box with 14k Gold.

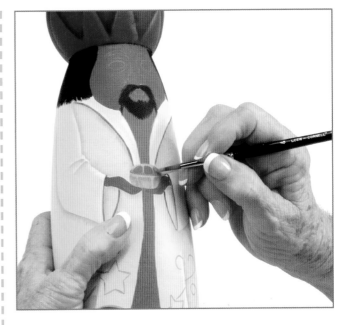

9 Paint the inserts on the box lid with Laguna.

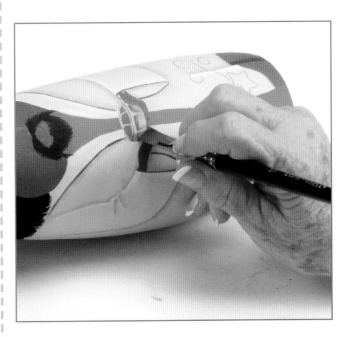

10 Use the #12 flat to shade the box with Burnt Sienna.

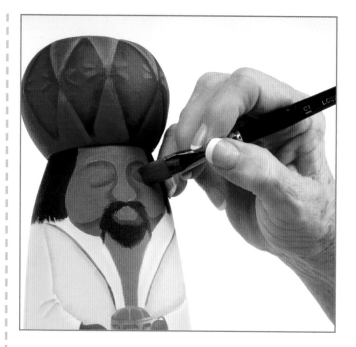

11 Shade the face and hands with Brown Iron Oxide. Fill in the mouth and nostrils with the same color.

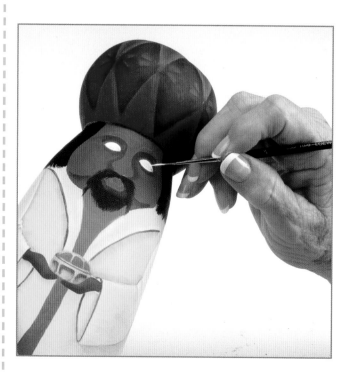

12 Fill the eyes in solid with White. This allows you to check and see if they are level and the same size.

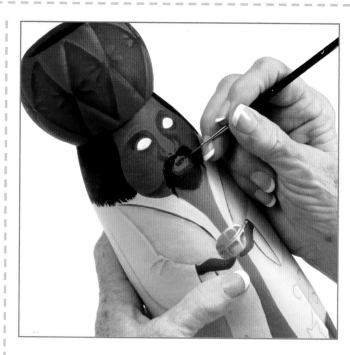

13 Apply blending gel to the cheeks and float Adobe across the area. Mop to soften and blend.

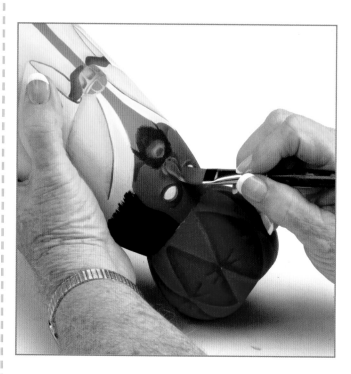

14 Highlight the eyelids, down the bridge of the nose, the tops of the cheeks, and lower lip with Light Chocolate.

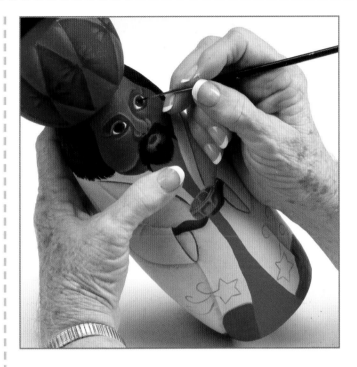

15 Use the liner brush and Brown Iron Oxide to paint the irises.

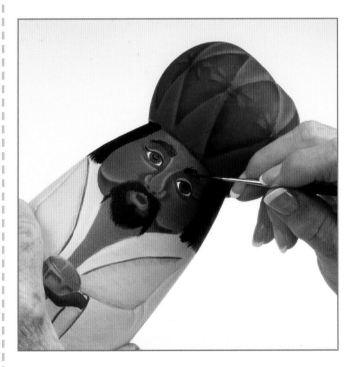

16 Use the liner brush and Black along the lash line and for the brows.

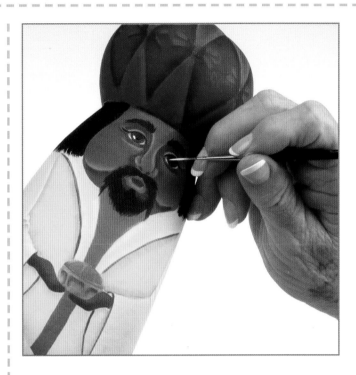

17 Place a White comma stroke in each eye.

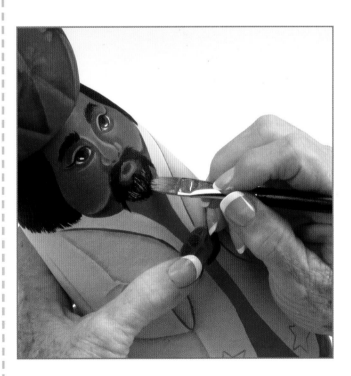

18 Use the filbert rake and Bridgeport Grey to highlight the hair and beard. Finish with several light coats of spray varnish. When dry, glue a red rhinestone on the turban in the center of each "x" and a single clear rhinestone on the box top.

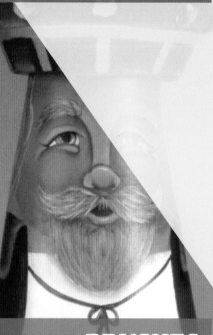

PALETTE
Delta Ceramcoat

–Burnt Sienna
–Georgia Clay
–Blueberry
–Cape Cod Blue
–Storm Grey
–Paynes Grey
–Blue Lagoon
–Autumn Brown
–Spice Tan
–14k Gold
–White
–Black
–Rain Grey
–Quaker Grey
–Medium Flesh
–Nightfall Blue
–Chambray Blue

BRUSHES
Loew-Cornell

–Series 7300 #2, 12 flats
–Series 7350 10/0 liner
–Series 7520 1/4" filbert rake
–Series 7550 1" wash brush

SUPPLIES

–12-14" tall club gourd
–Gourd pieces
–Blending gel
–Rhinestones
–Glue gun
–Wood glue
–Scrap 1/4" plywood
–Fast n' Final spackle

Assembly

Cut the gourd piece per diagram for the crown, cut a piece of plywood to fit inside (for the candle to sit on), and spackle any cracks between the gourd and wood. If necessary, cut the top of the club gourd off and fit the crown on top of the club. Glue in place and let dry several hours or overnight. *See illustration on page 70.*

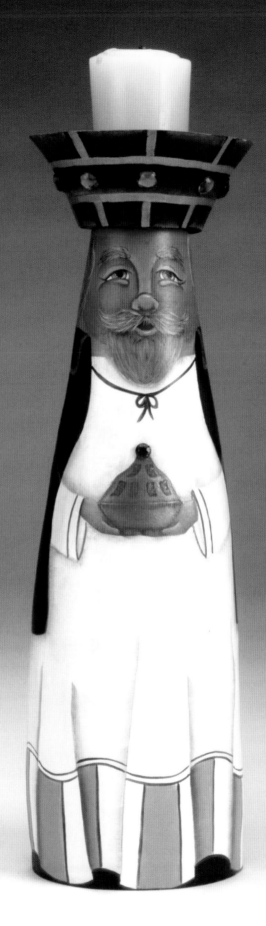

Blue Magi

PAINTING the PIECE

Basecoat the crown and cape Blueberry, the face and hands with a mix of Georgia Clay, Medium Flesh, and Autumn Brown 2:1:* *(note: the (*) denotes a touch of Autumn Brown)*, the gown White, the hair Brown, and beard Storm Grey. The gift is Spice Tan.

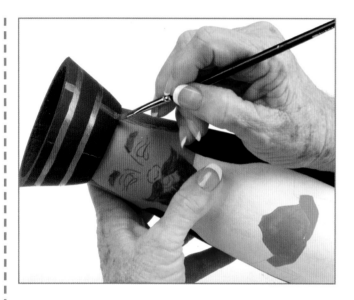

1 Divide the crown into three equal parts horizontally and eight equal parts vertically. Use the #2 flat to paint the lines first Spice Tan and then 14k Gold. Apply the face pattern and outline the features using the liner and thinned Burnt Sienna.

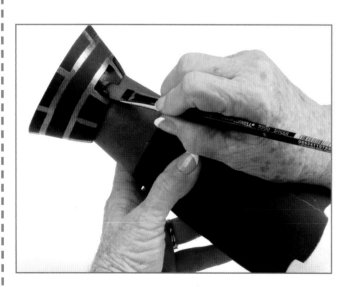

2 Use the #12 flat and Black to shade on each side of and under the gold lines.

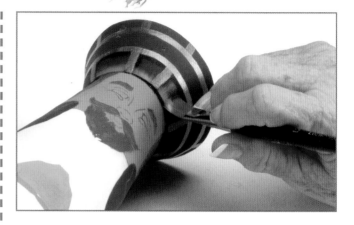

3 Use a mix of Blueberry and White 1:1 to highlight the crown.

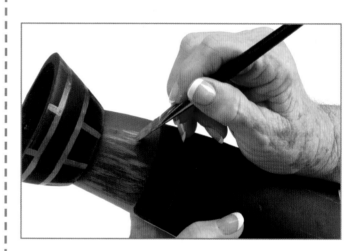

4 Use the rake brush and thinned Rain Grey to highlight the hair. Add a few strokes of White for highlight.

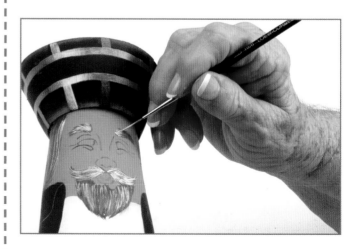

5 Use the liner brush and Rain Grey to highlight the brow.

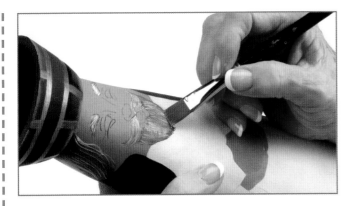

6 Use the rake brush for the beard.

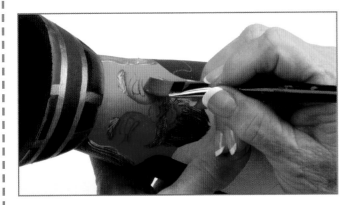

7 Use the #12 flat and Burnt Sienna to shade under the brow, down each side of the nose, under the eyes, nose, and lip. Fill the mouth and nostrils in solid with Burnt Sienna.

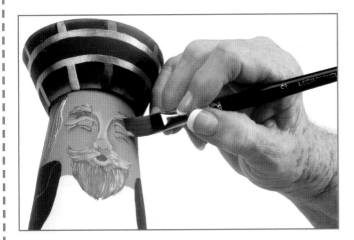

8 Use Medium Flesh to highlight down the bridge of the nose, the eyelids, and the wrinkles around the eyes.

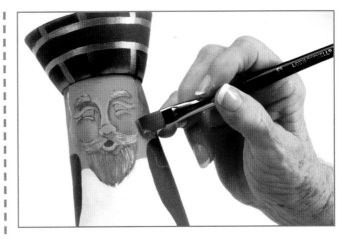

9 Apply blending gel and float Adobe across the cheeks. Mop to blend.

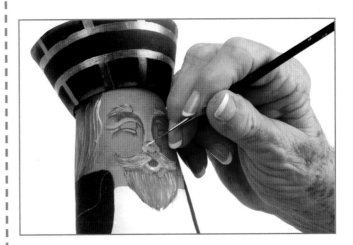

10 Use the liner brush and White to place a comma stroke on the nose.

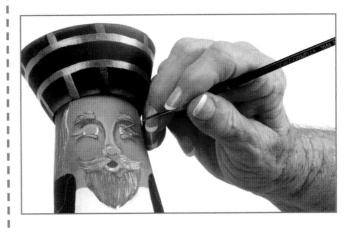

11 Use the liner brush to fill the eyes in solid with White and to paint the irises Cape Cod.

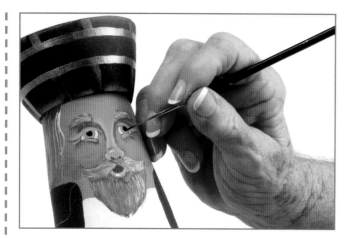

12 Paint the pupils Black using the liner brush.

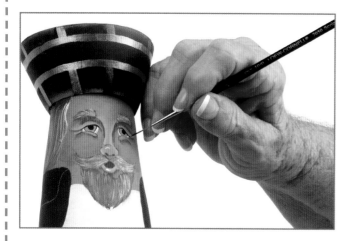

13 Use the liner and Black across the bottom of the eyelid.

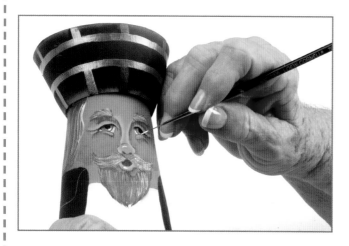

14 Place a White comma stroke in each eye.

15 Shade the cape with Paynes Grey.

16 Highlight the cape with White.

17 Use the wash brush to wash the entire area with Blueberry.

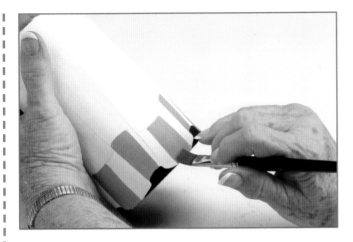

18 The stripes on the gown and the sleeves are Cape Cod.

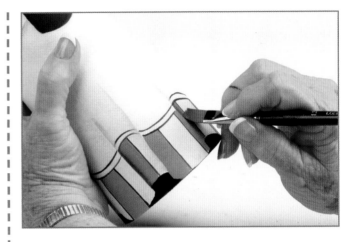

21 Shade the Cape Cod areas of the gown with Nightfall.

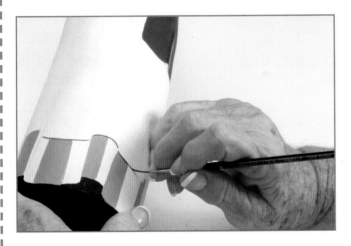

19 The stripes on the gown and the sleeves are edged with Blueberry.

22 Overpaint the gift with 14k Gold.

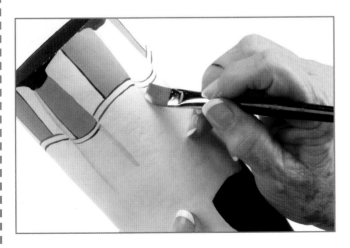

20 Shade the white areas of the gown with Chambray Blue.

23 Shade the gift with Burnt Sienna. Finish with several light coats of spray varnish. Glue a rhinestone on top of the gift.

PALETTE
Delta Ceramcoat

–White
–Black
–Spice Tan
–Seminole
–Burnt Sienna
–Autumn Brown
–Amethyst
–Roman Stucco
–Rain Grey
–AC Flesh
–Georgia Clay
–14k Gold
–Old Parchment
–Medium Flesh
–Bridgeport Grey
–Raw Sienna
–Azure Blue
–Navy Blue
–Blue Danube

BRUSHES
Loew-Cornell

–Series 7300 #12 flat
–Series 7350 10/0 liner
–Series 7520 1/4" filbert rake
–Series 7550 1" wash brush
–#275 1/2" mop

SUPPLIES

–9-10" tall pear-shaped gourd
–Gourd pieces
–Glue gun
–1/4" plywood scrap
–Wood glue
–Blending gel
–8 clear rhinestones

Assembly

Cut the gourd piece per diagram and cut a piece of plywood to fit inside it. Glue in place. Place the crown on the pear gourd and glue. Allow to dry several hours or overnight. *See illustration on page 72.*

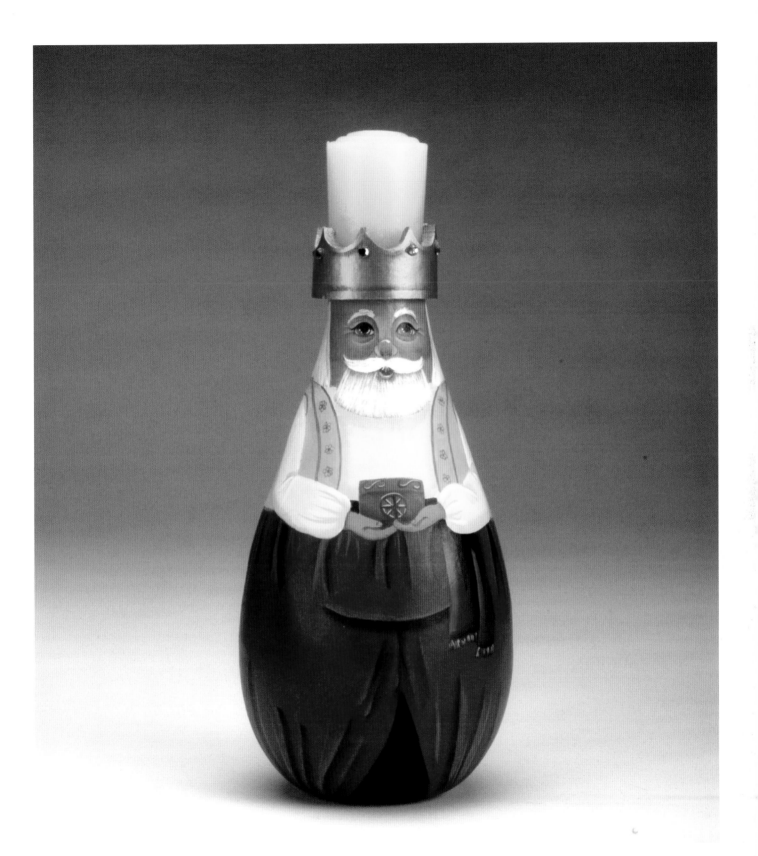

Purple Magi

PAINTING the PIECE

Apply the pattern and basecoat the crown Spice Tan then 14k Gold, the face and hands with a mix of Georgia Clay, Medium Flesh. and Autumn Brown 2:1:* (*note: the (*) denotes a touch of Autumn Brown*), the hair Rain Grey, the shirt a mix of Old Parchment + White 1:1, the vest in Roman Stucco, the pants in Amethyst, the box Raw Sienna and the sash Azure Blue. The space between the legs is Black. Use the liner brush and Burnt Sienna to outline the features and fill the eyes in solid with White.

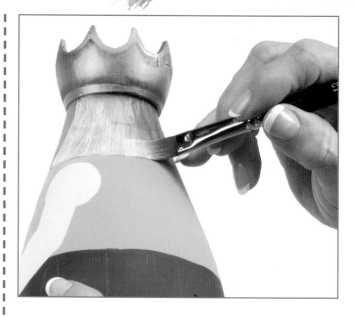

3 If the hair still looks too grey, wash the area with White.

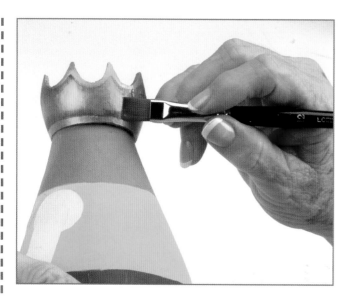

1 Use the #12 flat and Raw Sienna to shade the crown.

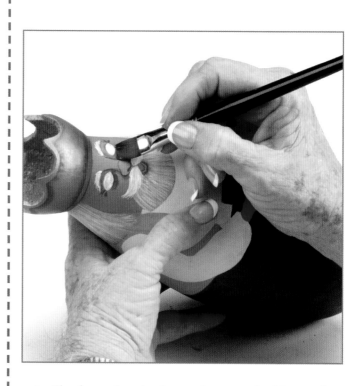

4 Shade under the brow, down each side, under the nose, and in the wrinkles with Burnt Sienna.

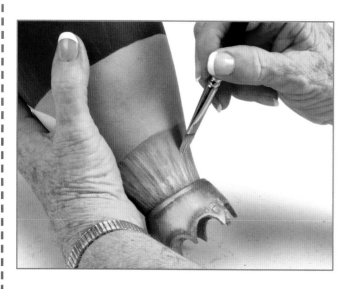

2 Use the rake brush and thinned White to overstroke the hair areas.

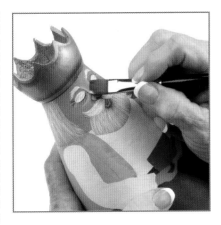

5 Highlight down the bridge of the nose, across the tip.

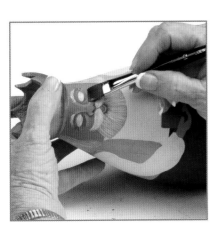

6 On the opposite sides of the wrinkles shade with Medium Flesh.

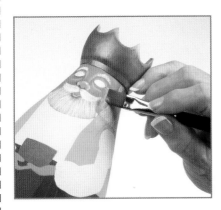

7 Apply blending gel and float Georgia Clay across the cheeks. Mop to blend and soften.

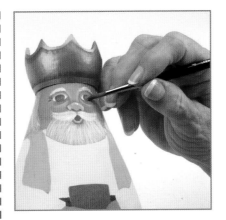

8 Paint the irises Seminole.

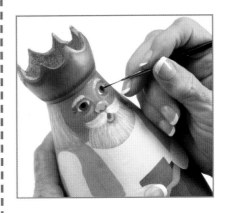

9 Paint the pupils Black.

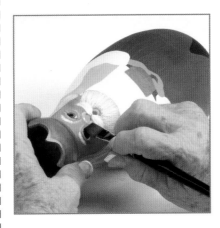

10 Use a very light touch and float Black across the eyes just under the eyelid.

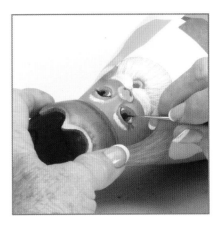

11 Use the liner brush and Black to make a very thin line across each eyelid on the lash line.

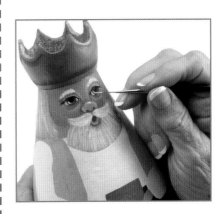

12 Place a White comma stroke in each eye.

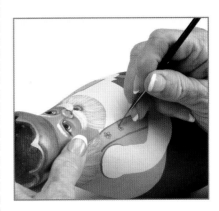

13 Use Raw Sienna and the liner brush to make the trim on the front of the vest.

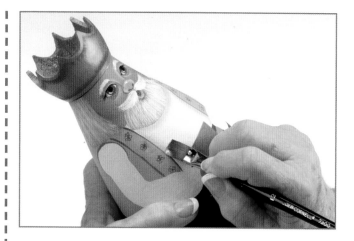

13 Shade the shirt with AC Flesh.

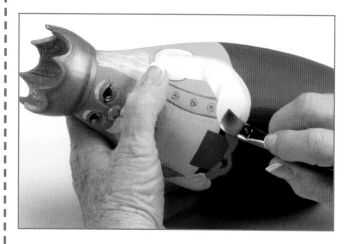

14 Highlight the shirt with White.

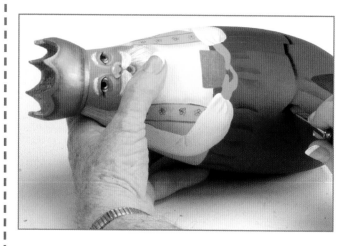

15 Shade the pants with Black.

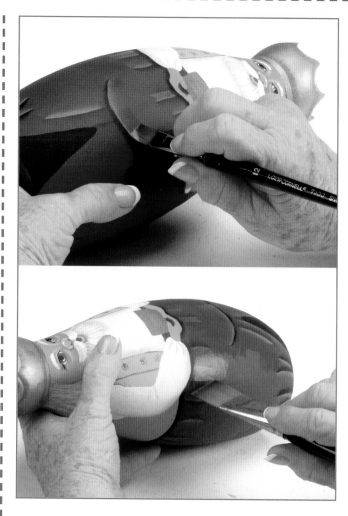

16 Highlight the pants with a mix of Amethyst + White 1:1.
Wash with Amethyst when dry.

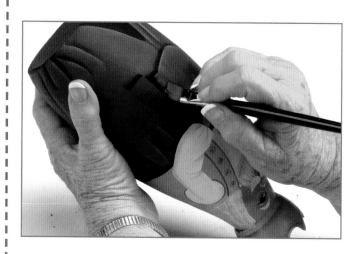

17 Shade the sash with Navy Blue.

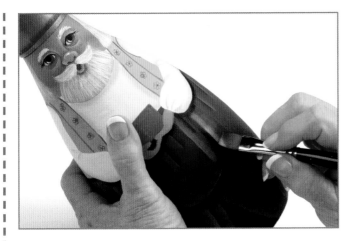

18 Use the #12 flat to highlight the sash with Blue Danube.

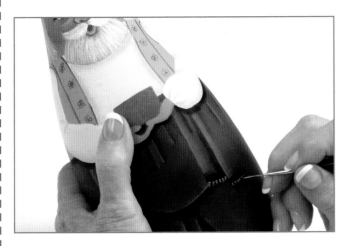

19 Use the liner brush and Azure Blue to make the fringe.

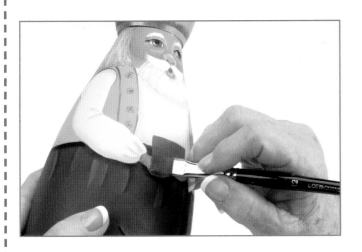

20 Use the #12 flat to shade the hands with Burnt Sienna.

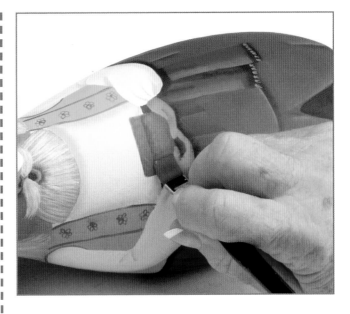

21 Shade the box with Burnt Sienna.

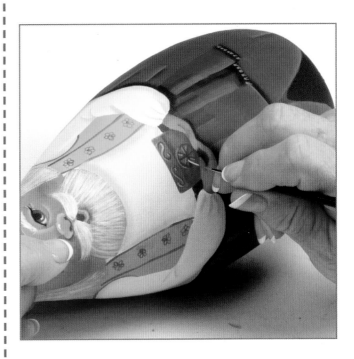

22 Highlight the box with Roman Stucco. Finish with several light coats of spray varnish. When dry, use the glue gun to apply the rhinestones to the crown.

Patterns

Baby Chimp

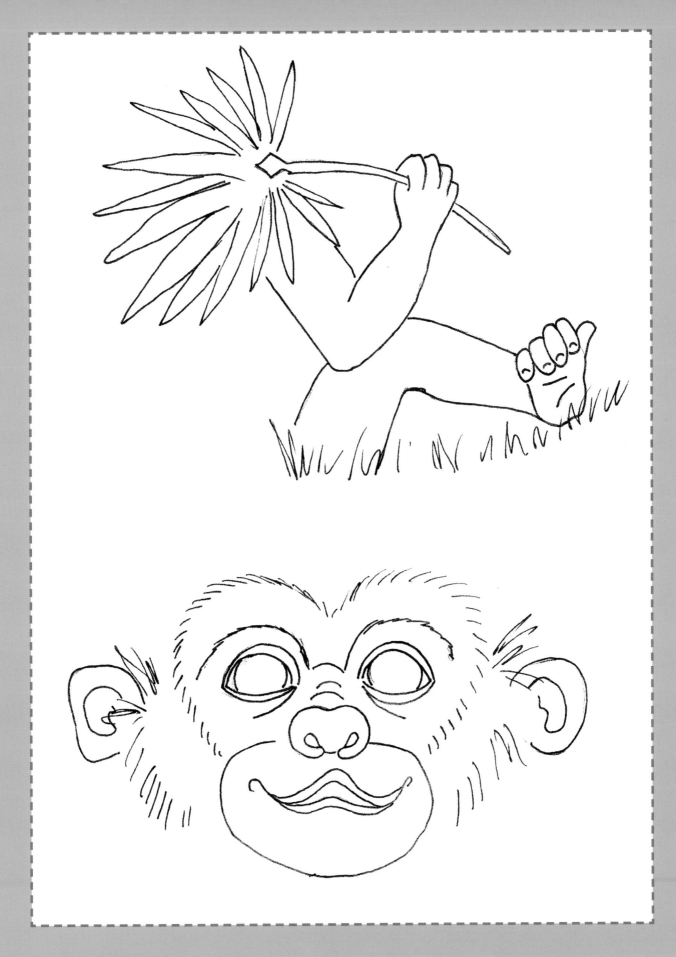

Baby Chimp

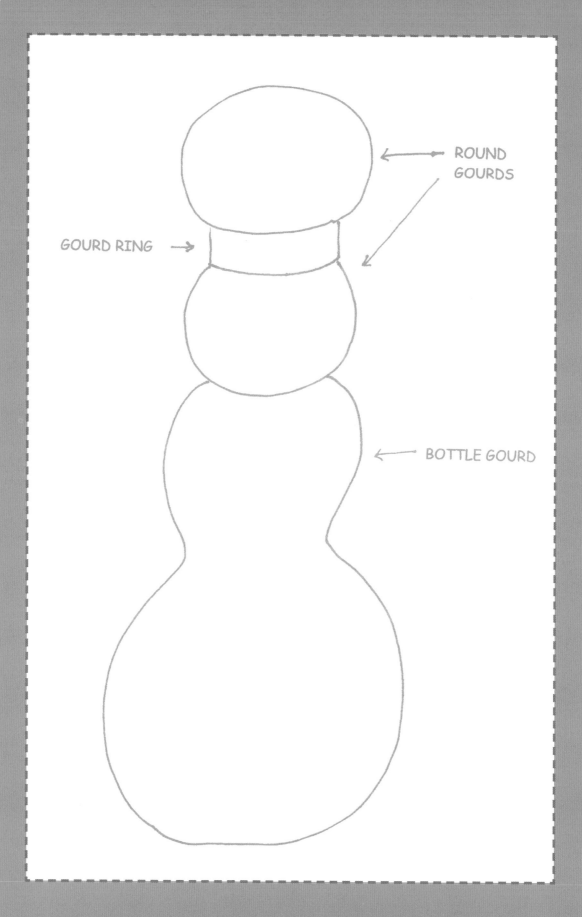

ROUND
GOURDS

GOURD RING →

BOTTLE GOURD

Baker Snowman

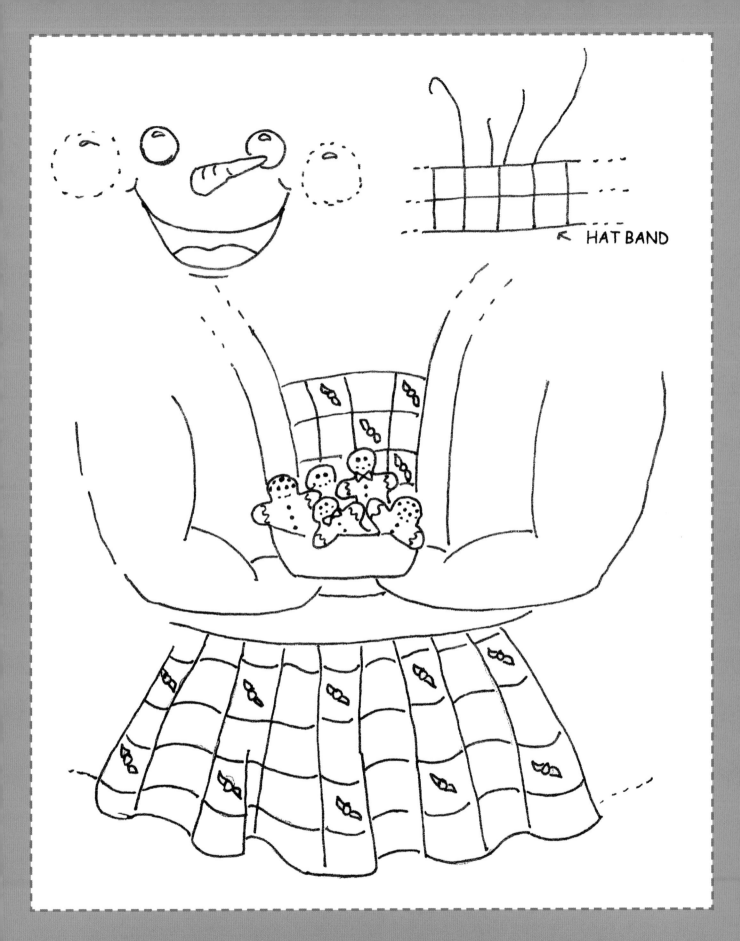

HAT BAND

Baker Snowman

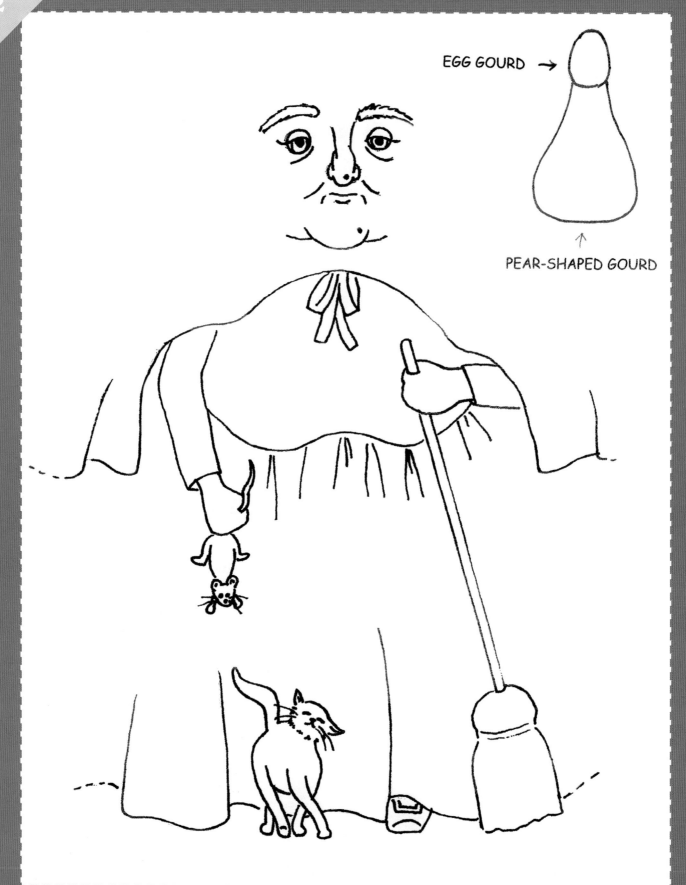

EGG GOURD →

PEAR-SHAPED GOURD

Witch with Rat and Cat

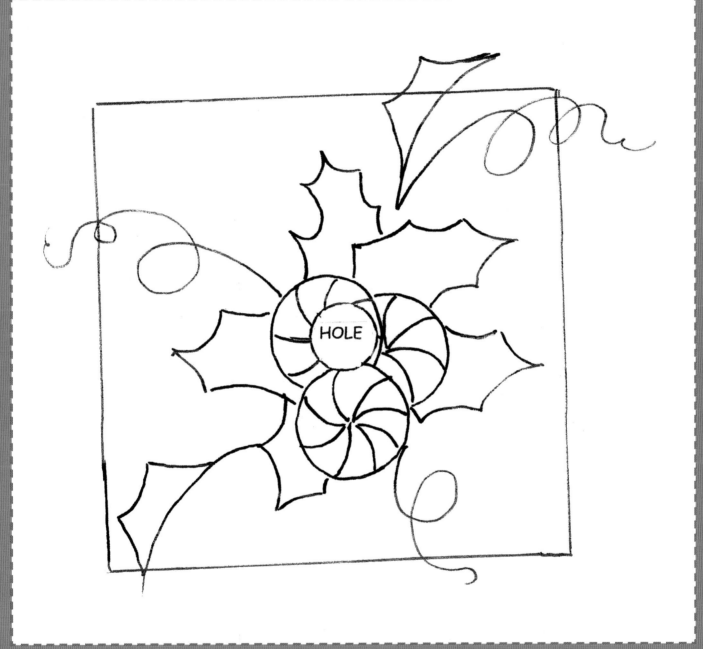

Christmas Oil Lamp

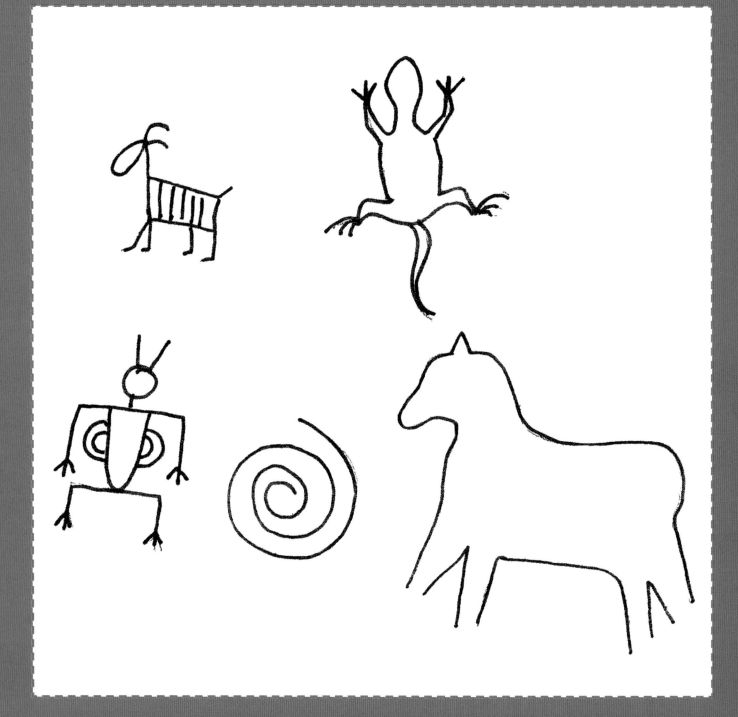

Petroglyph Wall Pocket

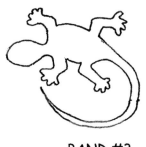

ROTATE GECKO 180 DEGREES
EACH TIME YOU USE IT

BAND #3

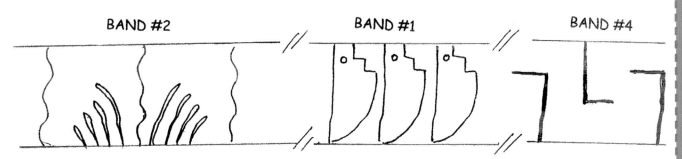

BAND #2

BAND #1

BAND #4

START EACH BAND IN THE
CENTER OF THE GOURD AND
WORK TOWARD THE SIDES.
REPEAT AS NEEDED.

Southwest Wall Pocket

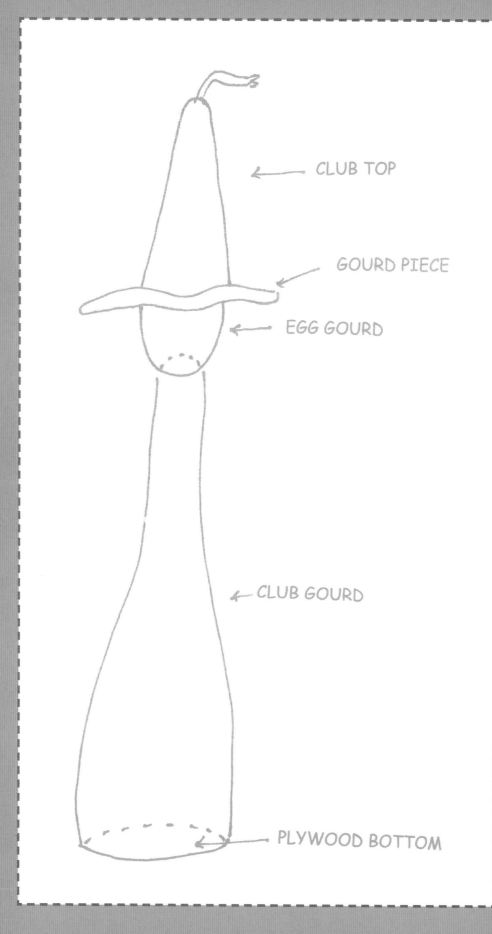

CLUB TOP

GOURD PIECE

EGG GOURD

CLUB GOURD

PLYWOOD BOTTOM

Witch in Training

ADJUST LENGTH HERE

"CAUTION"
STUDENT
DRIVER

Witch in Training

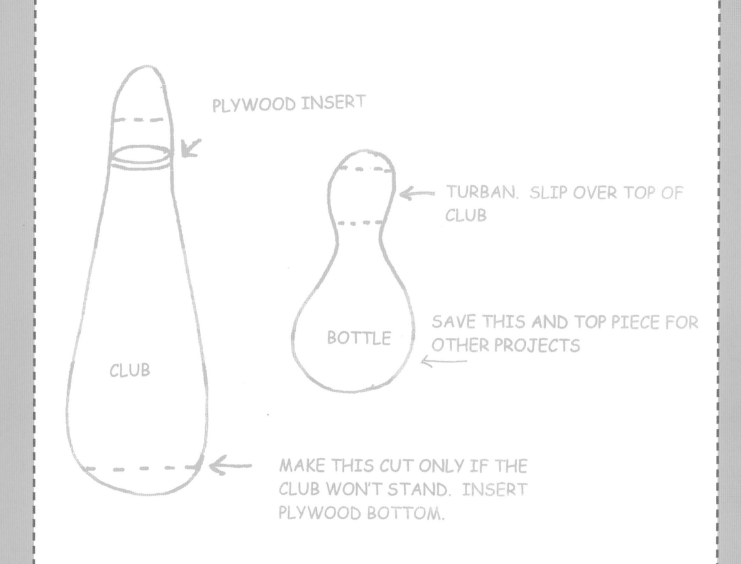

PLYWOOD INSERT

TURBAN. SLIP OVER TOP OF CLUB

CLUB

BOTTLE

SAVE THIS AND TOP PIECE FOR OTHER PROJECTS

MAKE THIS CUT ONLY IF THE CLUB WON'T STAND. INSERT PLYWOOD BOTTOM.

Yellow Magi

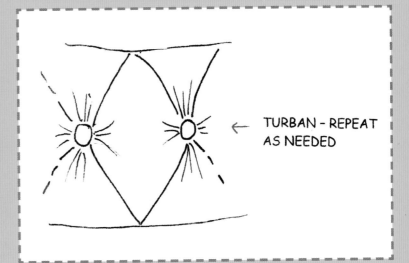

← TURBAN - REPEAT AS NEEDED

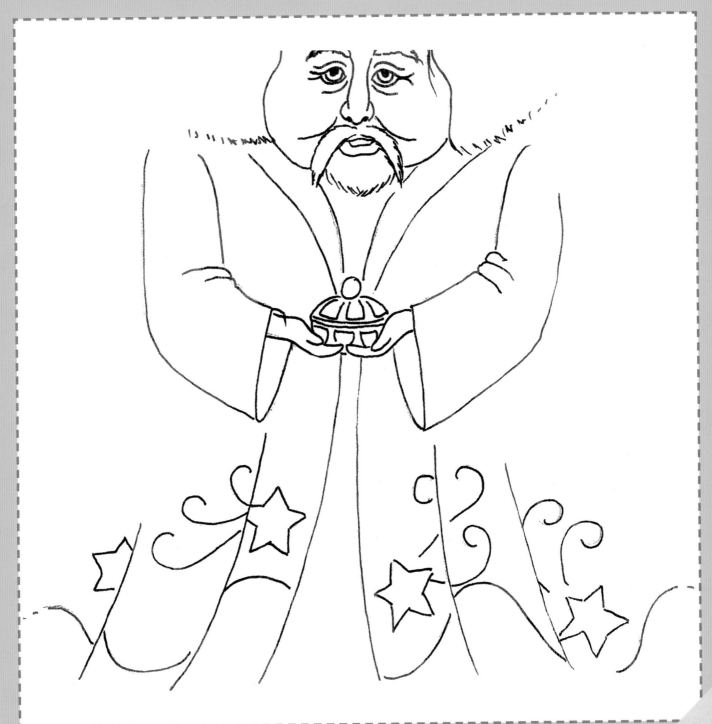

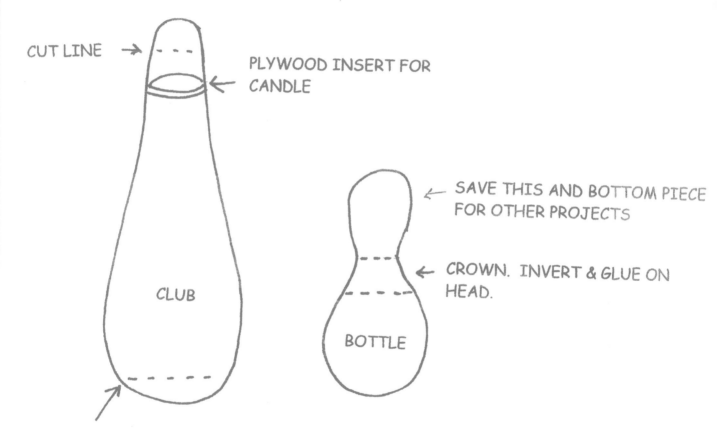

CUT LINE →

PLYWOOD INSERT FOR CANDLE

SAVE THIS AND BOTTOM PIECE FOR OTHER PROJECTS

CROWN. INVERT & GLUE ON HEAD.

CLUB

BOTTLE

MAKE THIS CUT ONLY IF THE CLUB WON'T STAND AND INSERT PLYWOOD BOTTOM.

Blue Magi

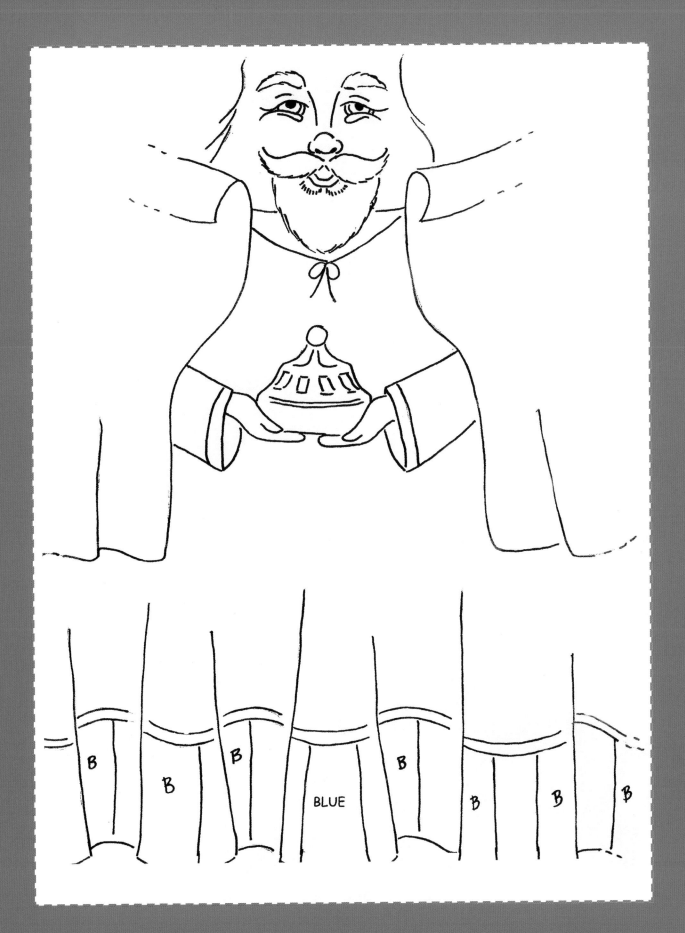

Blue Magi

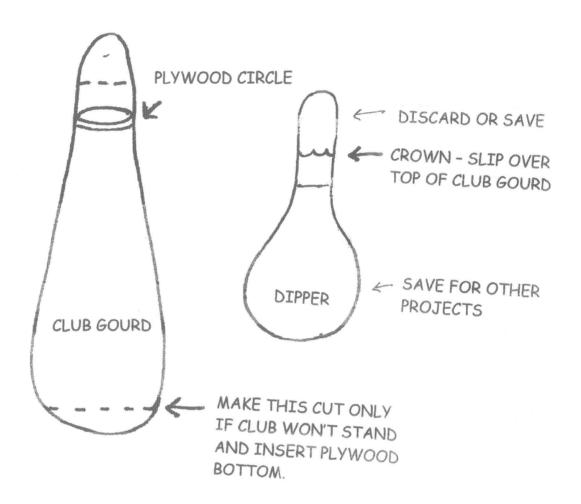

PLYWOOD CIRCLE

DISCARD OR SAVE

CROWN – SLIP OVER
TOP OF CLUB GOURD

DIPPER

SAVE FOR OTHER
PROJECTS

CLUB GOURD

MAKE THIS CUT ONLY
IF CLUB WON'T STAND
AND INSERT PLYWOOD
BOTTOM.

DIVIDE TOP OF CROWN INTO 8
EQUAL SECTIONS & SCALLOP
BETWEEN DOTS TO GET THE
POINTS. CUT OUT PER PHOTO &
GLUE ATOP THE CLUB.

Purple Magi

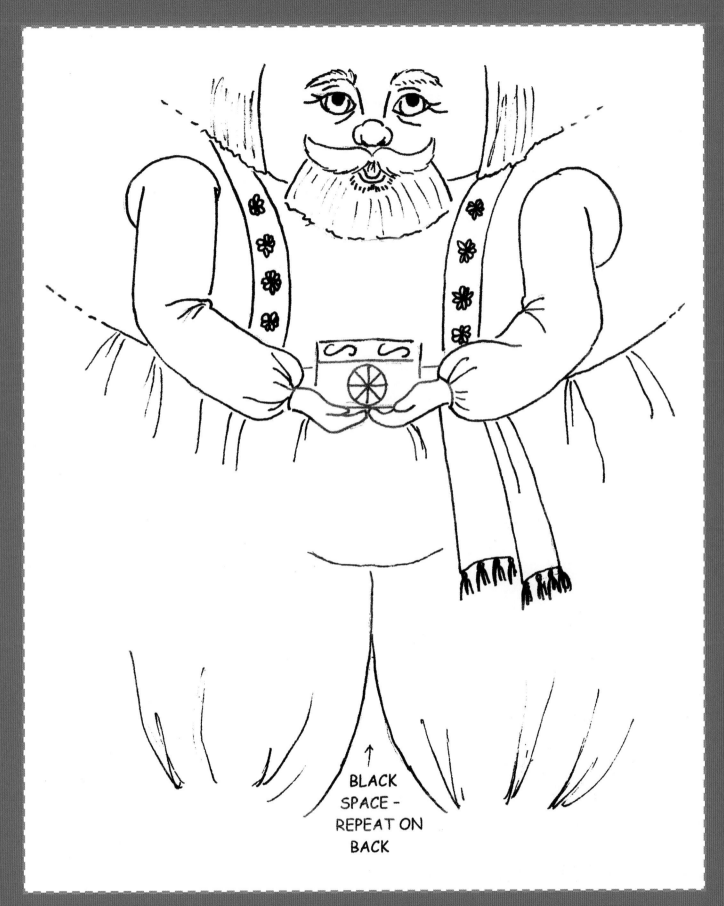

BLACK
SPACE -
REPEAT ON
BACK

Purple Magi

Gallery

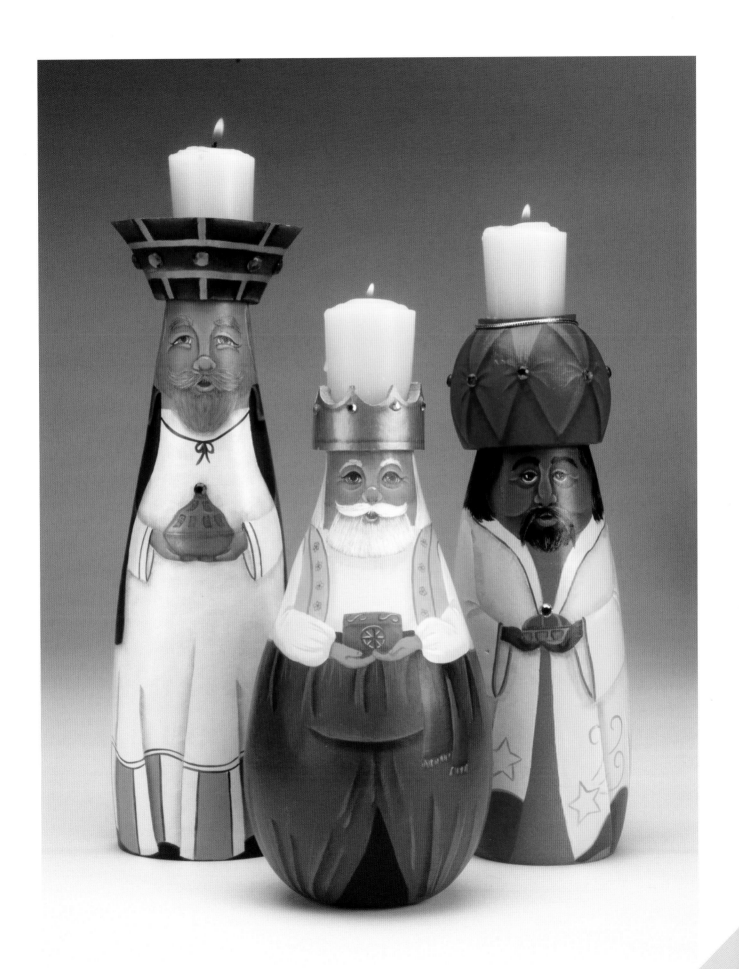

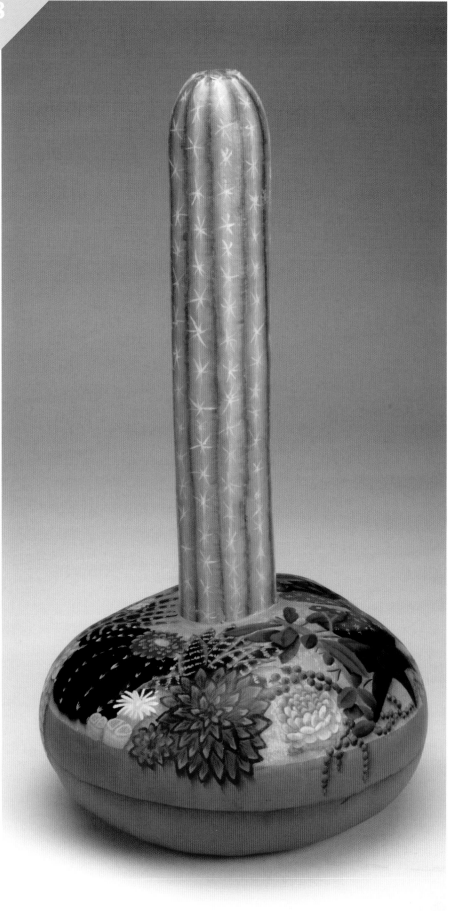

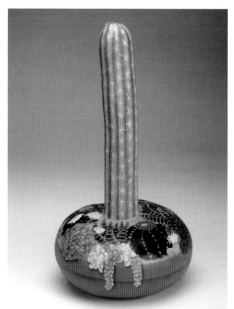

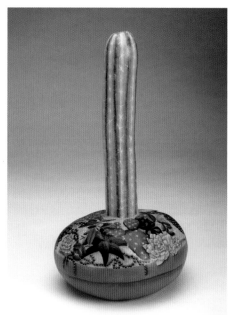

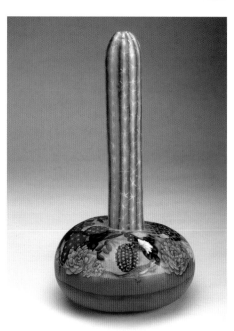

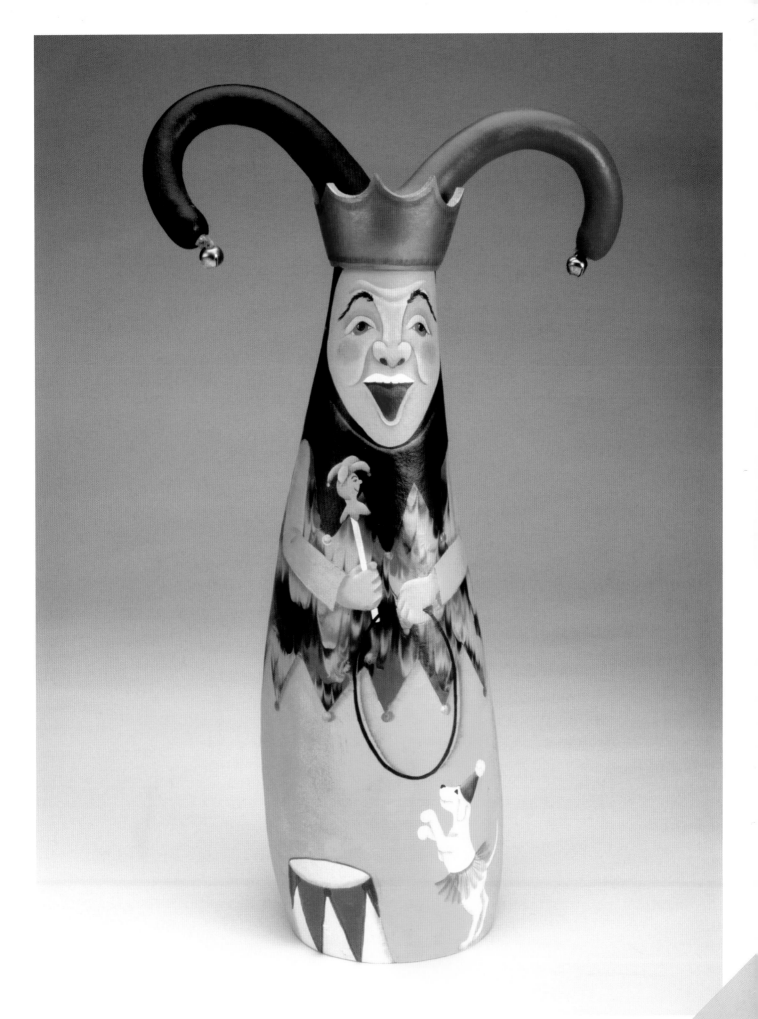

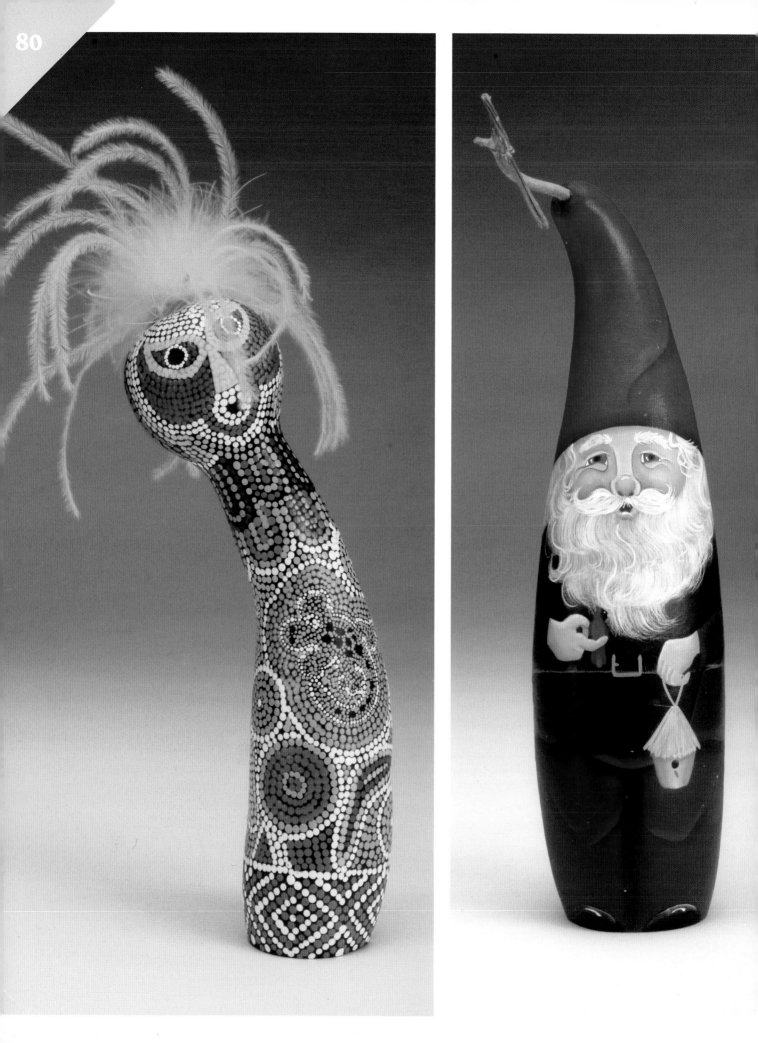